ANSEL ADAMS AT 100

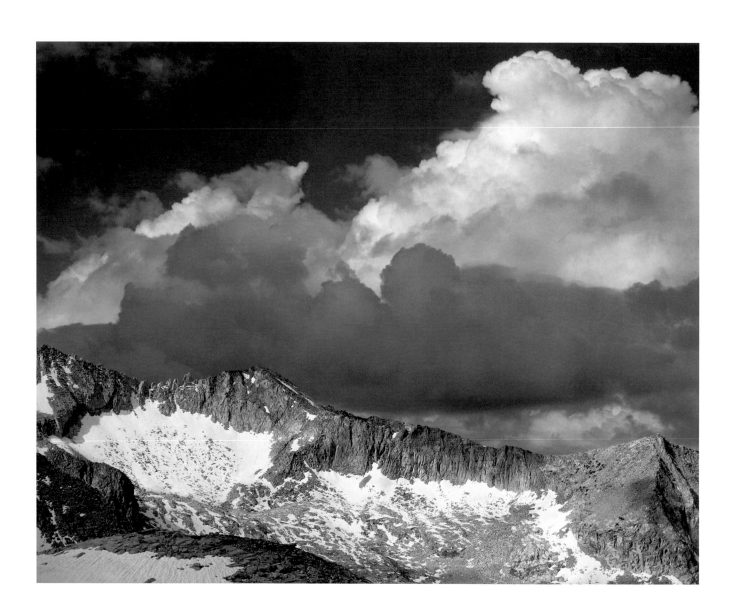

ANSEL ADAMS AT 100

John Szarkowski

Foreword by Sandra S. Phillips

Little, Brown and Company Boston • New York • London

In association with the San Francisco Museum of Modern Art

In 1976, Ansel Adams selected Little, Brown and Company as the sole authorized publisher of his books, calendars, and posters. At the same time, he established The Ansel Adams Publishing Rights Trust in order to ensure the continuity and quality of his legacy—both artistic and environmental.

As Ansel Adams himself wrote, "Perhaps the most important characteristic of my work is what may be called print quality. It is very important that the reproductions be as good as you can possibly get them." The authorized books, calendars, and posters published by Little, Brown have been rigorously supervised by the Trust to make certain that Adams' exacting standards of quality are maintained.

Only such works published by Little, Brown and Company can be considered authentic representations of the genius of Ansel Adams.

First paperback edition

A larger format clothbound edition, with slipcase, is also published by Little, Brown and Company for general trade distribution.

Library of Congress Cataloging-in-Publication Data
Szarkowski, John.
Ansel Adams at 100 / John Szarkowski.
p. cm.
"In association with the San Francisco Museum of Modern Art."
ISBN 0-8212-2515-4 (hardcover)
ISBN 0-8212-2753-X (paperback catalog)
1. Photography, Artistic—Exhibitions. 2. Adams, Ansel, 1902–84—Exhibitions.
I. Adams, Ansel, 1902–84. II. San Francisco Museum of Modern Art. III. Title.
TR647.A236 2001
770'.92—dc21
[B] 00-069941

PRINTED IN THE UNITED STATES OF AMERICA

Frontispiece: CLOUDS, KINGS RIVER DIVIDE, SIERRA NEVADA, 1936 (1935)

Ansel Adams at 100 is published in celebration of the one-hundredth anniversary of the birth of Ansel Adams and on the occasion of the centennial exhibition *Ansel Adams at 100*, directed by John Szarkowski and organized by the San Francisco Museum of Modern Art. The exhibition is made possible by Hewlett-Packard Company.

CENTENNIAL EXHIBITION

August 4, 2001–January 13, 2002	San Francisco Museum of Modern Art
February 20–June 2, 2002	The Art Institute of Chicago
July 4–September 22, 2002	The Hayward Gallery, London
October 10, 2002–January 5, 2003	Kunstbibliotek, Berlin
February 2–April 27, 2003	Los Angeles County Museum of Art
July 9–November 4, 2003	The Museum of Modern Art, New York

Hewlett-Packard is proud to sponsor the international tour of *Ansel Adams at 100*, a major exhibition organized by the San Francisco Museum of Modern Art on the occasion of the centennial of the birth of this great photographer. The exhibition celebrates Adams' achievement as an artist, bringing together the finest examples of work by perhaps the most widely recognized figure in the history of photography.

Adams was an individual of tremendous—and tremendously varied—talents. He was an energetic advocate for photography as an expressive modern art form at a time when this was still considered a challenging idea. Adams' advocacy did not stop with aesthetics, for he employed his art progressively to further the important cause of environmental conservation, thereby revealing the power of photography to reach people in all walks of life. And perhaps most pertinent to this exhibition, Adams was dedicated to testing the limits of his craft. His endeavor to discover the full capabilities of the photographic

technology he used is what enables us now to have the privilege of viewing such pictures of beauty and flawless craftsmanship.

The values embodied by Ansel Adams are shared by HP. Not only are we dedicated to innovation and excellence in a broad range of digital products and services, we are committed to making the power of new technologies available to everyone. In Adams we find a paragon, for HP likewise believes that originality, driven by the highest standards of quality, can fuel the machinery of social change.

Again, we are pleased to be part of the centennial celebration of Ansel Adams. Our sponsorship of *Ansel Adams at 100* affirms our appreciation for the art of photography as a powerful means of invention and communication.

Carly Fiorina
President and CEO
Hewlett-Packard Company

In 1935 Ansel Adams published a remarkable book, *Making a Photograph,* in which he proposed that any camera image, even a landscape, might be regarded as documentary, insofar as "contemporary thought [is] reflected in the aesthetic conception of the photographer. The painting of El Greco documents the aesthetic and intellectual attitude of his period, that of Picasso, our present day. The most important contemporary photography is that which relates to the contemporary scene and contemporary aesthetic tendencies." As it happened, the year 1935 also marked the founding of this museum, from the outset an institution devoted to exhibiting "modern art and material having a definite bearing on the contemporary," as the Museum's founding director, Grace McCann Morley, put it at the time. That both Ansel Adams and SFMOMA made San Francisco home — indeed, that the histories of this artist and this museum should so happily and meaningfully intersect — is but one of the reasons we now take pride in celebrating the lifetime accomplishments of our most beloved native son.

Adams was one of photography's great champions, here and afield, at a time when its recognition as an expressive art form was hardly universal. He was crucial in ensuring that photography be made a charter aspect of the Museum's creative program, and his own prints were among the first in our collection. An exhibition of his photographs was presented here as early as 1939; the next year Adams offered the Bay Area a major exhibition of historical photography organized for the Golden Gate International Exposition. He went on to help establish the photography department at The Museum of Modern Art in New York and the curriculum in photography at the California School of Fine Arts (now the San Francisco Art Institute), demonstrating his commitment to the future of

the medium as much as to its present and past. In 1956 he helped persuade Georgia O'Keeffe to make available a survey of photographs by her late husband, Alfred Stieglitz, to this museum, securing for West Coast audiences the opportunity to appreciate the handiwork of this influential master. Throughout his career, Adams never loosened his conviction that San Francisco regard itself as a major center for the study and appreciation of photography as an art.

But *Ansel Adams at 100* is not about Adams the citizen or Adams the activist; it is about Adams the artist. We are delighted that the dean of photographic curators, John Szarkowski, has assembled for us an exhibition whose purpose is as necessary and challenging as it is straightforward: to contemplate Adams' achievement as a practicing photographer by training our attention on the images best demonstrating that alchemy commonly referred to as "the creative process." It is, after all, one of the duties of an art museum to disentangle an artist's work from what we think we know about it, to revisit, reexamine, and reevaluate the art that has defined our times and makes us modern. With a figure as seemingly familiar as Adams, no more brilliant illustration of this proposition could be imagined.

We have been exceptionally fortunate to be joined in this endeavor by Hewlett-Packard. Their most generous contribution is manifest in many aspects of the exhibition's international tour, not least of all in the educational materials and programming that have been created as a complement to Adams' stunning photographs. For their support and enthusiasm for this project, our gratitude goes especially to Carly Fiorina, chief executive officer, president, and chairman; Pradeep Jotwani, president, Consumer Business Organization; Allison Johnson, vice president, HP Brand and Communications; and Doug Cole, worldwide brand sponsorship manager.

Many SFMOMA staff members contributed their expertise to *Ansel Adams at 100*, and a number of them have been thanked in the acknowledgments that appear at the end of this volume. Sandra S. Phillips, senior curator of photography, and Douglas R. Nickel, curator of photography, have played key roles in this project since its inception, and it has benefited from their attentiveness and enthusiasm.

And finally, sincere thanks are due William Turnage, John Schaefer, and David Vena, trustees of the Ansel Adams Publishing Rights Trust, who entertained the suggestion that SFMOMA host *Ansel Adams at 100*. We are particularly indebted to Turnage, whose exacting standards, devotion to quality, and visionary leadership have fundamentally shaped this exhibition and its publications and whose patience and tact ensured that the project would come to fruition.

David A. Ross
San Francisco Museum of Modern Art

ANSEL ADAMS AND SAN FRANCISCO

Sandra S. Phillips

Ansel Adams identified deeply with the culture and geography of the American West, and this is how we visualize him—in a portrait by his friend Nancy Newhall, his profile set against the open sky, the familiar Stetson pulled back as he adjusts the camera lens; or, in another, standing on his car platform above the noble forms of Yosemite Valley, preparing his camera. When Newhall and her husband, Beaumont, first met Adams in New York in 1939, they were surprised by his western appearance: not only his clothing but also his bearing, his friendliness and openness in a city where business attire and elegant manners— at least in those years—were customary.

Adams was also a man of intelligence and ambition who saw the West as integral to our national culture, and photography as an extension of modern art. He worked to make western American art informed and dynamic, and to convince his eastern friends not only of the West's special beauty but of the creative gifts of its best artists. Adams' history—and by extension, an important chapter in the history of American photography— was intimately tied to San Francisco, his home, and to the individuals and institutions that made the city an increasingly vital center for photographic culture in the years spanned by this exhibition.

In the spring of 1933 Adams returned to California from his first visit to New York, a journey that included meeting the oracle of American modernism, Alfred Stieglitz. Adams, who fully understood Stieglitz's role as well as his demanding personality, initiated a steady correspondence with the older man, which lasted until Stieglitz's death in 1946. He admired Stieglitz not only as an innovative photographer but also as a protector, promoter, and mentor of artists. In his first letter to Stieglitz, dated June 22, 1933, Adams wrote that he had leased studio space in downtown San Francisco in order to open a gallery that would feature "the

most important and significant phases of photography." Though he felt obliged to deny such an explicit relationship, Adams clearly intended to form a Northern California center modeled on Stieglitz's gallery An American Place. "I may go down to ignominious defeat," Adams continued, "but I am willing to take the chance. Someone here has to take the first step, and I have chosen to do so. Pray for me."[1]

Although Adams' gallery venture proved short-lived—lasting less than a season, closing in the spring of 1934—it helped ameliorate his sense of remove from the more vital and extensive art activity in New York and affirmed an avant-garde artistic community in his own territory. Adams' ambitions for his gallery are revealed in a letter to Paul Strand:

> I am trying to bring things to San Francisco that should have come many years ago. Despite a certain sneering attitude in the East about California I can truthfully say to you that I would rather live here and work here than in any other American city I have seen....There *is* a vitality and a purpose, and a magnificent landscape....There are some of the good qualities of New York here, and a few of the bad ones.[2]

Adams had played an important role in the local photography and art community before his trip to New York, but his visit with Stieglitz emphasized the sparse and provincial audience for modernism at home, perhaps even his loneliness for artistic companionship and intellectual challenge. In 1931 he had begun a series of reviews on photography for the San Francisco–based literary magazine *The Fortnightly*, in which he discussed the work of Eugène Atget, Edward Weston, Imogen Cunningham, László Moholy-Nagy, and Willard Van Dyke—a judicious mixture of international artists and local talent. In an indirect way he was probably trying to support the perilous but prescient interest of

Lloyd Rollins, the young new director of the M. H. de Young Memorial Museum, to exhibit photography.[3] Adams and Van Dyke were the catalysts and organizers of the 1932 Group f/64 show at the de Young, the exhibition that aspired to define a high form of modernist art that photography had achieved in the West. Two years later Adams sought support from the Guggenheim Foundation, but not for assistance to pursue his own photography. He wanted instead, as he stated:

> To engage in research related to Photography as a form of esthetic and social expression. To coordinate the history and development of Photography in America with the development of American art. To investigate contemporary Photography with especial emphasis on the following: (a) contemporary "pure" photography; (b) contemporary industrial photography; (c) the photo-document, and the social significance of Photography. To prepare an illustrated book on the above.[4]

When Stieglitz offered Adams an exhibition at his New York gallery in October 1936, a new museum had opened in Adams' hometown, one that would share some of his ambitions. In January 1935 the San Francisco Museum of Art (SFMA), the first museum of modern art in the West and the third such in the country, opened its inaugural show in the new Beaux Arts–style War Memorial Veterans Building opposite City Hall.

Founded by the San Francisco Art Association, the SFMA would always be allied with living artists and directed toward contemporary artistic expression, and at the beginning it would have rather close ties to the Museum of Modern Art in New York—although it would not be called the San Francisco Museum of *Modern* Art until 1975. The impetus to form the new institution grew directly out of the Panama-Pacific International Exposition held in San Francisco in 1915, two years after the celebrated

Armory Show in New York introduced radical European modernism to the United States.[5] The Pan-Pacific show included a reduced version of the Armory exhibition, along with other, more conventional examples of contemporary and historical art and the expected displays of industry. Years later Adams, who had a yearlong pass to the exposition, would cite it as a defining moment and could vividly recall not only the mechanical exhibits but also the art he had seen.

In late 1934 Dr. Grace L. McCann Morley was appointed to serve as the curator of the SFMA and several months later was named its director. Morley, a self-possessed, no-nonsense professional, educated both locally and abroad, was a Bay Area native.[6] Working far from the art centers of the East Coast and dependent upon a relatively unsophisticated audience of supporters, Morley made good use of the modest resources at her disposal to develop both a collection and a community for the SFMA. Throughout her twenty-three-year tenure, she possessed a sense of the high purpose of modernism and a devotion to local duty, which, among other things, informed the photography program she hoped to develop with Adams' aid.

One of Morley's most enthusiastic trustees was Albert Bender, a dapper, diminutive, and spirited Dublin-born insurance man fond of wearing fresh roses in his lapel. By the 1930s Bender had become one of San Francisco's foremost patrons of the arts; he supported local institutions and individual artists with often more enthusiasm than discrimination. Bender had a special affinity for his young protégé Adams and played a key role in Adams' career by promoting his first portfolio, *Parmelian Prints of the High Sierras* [sic] (1927), as well as his first illustrated book, *Taos Pueblo* (with Mary Austin, 1930). He also served briefly on the Committee on Photography at the Museum of Modern Art in New York, where, as in San Francisco, he was a generous donor of early Adams photographs.

In September 1939 Morley offered Adams his first exhibition at the San Francisco Museum of Art. Soon after, he organized an ambitious historical review of photography for the San Francisco Golden Gate International Exposition in 1940. Thus, along with creating and presenting his own work, Adams continued, even expanded, his public efforts to promote photography. *A Pageant of Photography*, as the 1940 exhibition was called, owed much to Beaumont Newhall's earlier survey of the field, *Photography: 1839–1937*, at the Museum of Modern Art in New York. Adams' show, like Newhall's, included historical and technological sections, but Adams also devoted significant space to both contemporary American photography and pictures made in California. He enlisted Morley to prepare a section and write an essay for the catalog on the history of the American movie, invited Newhall to contribute the essay "Photography as an Art," and solicited contributions from Dorothea Lange, László Moholy-Nagy, and Paul Outerbridge. Adams was determined to present a major historical overview of the medium with examples of the highest quality, accompanied by a beautiful and enlightened publication. He clearly understood the book to be a logical extension of his passionately held educational mission.

That fall Adams received a letter from David McAlpin, a trustee of the Museum of Modern Art in New York and a man with a deep interest in photography and a desire to see it included within the Museum. McAlpin, who already knew Adams, wrote, "I have accepted the chairmanship [of the newly established Committee on Photography] *provided* you would come and stay here and devote as much time as necessary and serve as advisor, organizer and policy director. And I have offered to underwrite your retainer."[7] It was a flattering offer, certainly tempered by the real demands of distance more palpable than now. But, in characteristic fashion, Adams was soon an energetic participant. He taught, suggested exhibitions, and deepened his

friendship with both Beaumont Newhall and his wife, Nancy. Adams overflowed with ideas and enthusiasm, and his knowledge of the field and appreciation of quality were valued complements to the more retiring, scholarly bearing of Newhall. Indeed, they made a perfect team.

There was a subtle but perceptible shift about this time in Adams' attitude toward his native territory. Although his family and most of his work remained in the West, his important friendships and artistic activity increasingly revolved around New York. Grace Morley must have sensed this, as she increasingly turned to him for advice and support. In early 1941 she received a letter from Evelyn D. Haas, newly married to Walter Haas Jr., the grandson of Adams' early patron Rosalie Meyer Stern. Evelyn Haas had come to San Francisco from New York, where she had worked with both the American Film Center in Rockefeller Center and the Museum of Modern Art. Morley discovered that Mrs. Haas had some experience and interest in journalistic photography, and wrote Newhall to solicit his help for a show Haas organized later that year for the Museum. The subject, contemporary war photography, coincided with exhibitions presented in the New York institution.[8] Morley also sought Adams' advice on the role of photography within the San Francisco Museum of Art, the kinds of exhibitions it should organize, and the audiences it should address. Adams' response was extensive, exuberant, and demanding: he advised that the Museum establish a photography department and develop a collection, form a relationship with the Museum of Modern Art's photography department to obtain important exhibitions, and distance itself from the overtures of local pictorialist amateurs. Morley may have been put off by the fullness of his intensity, and was probably distracted by the onset of war and the persistent lack of adequate support or funding for most of the Museum's needs.[9] She outlined the limitations of the SFMA photography program to an official of the Los Angeles Camera Club:

We are very much interested in photography, though it represents for us the subordinate interest in the arts of painting, sculpture and so forth. We do have the full intention, of course, of holding photographic exhibitions from time to time. As you know, we recently held an exhibition of the work of Ansel Adams, and we are shortly to hold one of the work of Brett Weston. Later on, we shall have group shows of our own selection, which represents all the emphasis which we feel in justice we can put on photography at this time.[10]

But even such frustrating, diplomatic language could not dissipate the serious local interest in photography that Adams had fostered. By 1945 both the California School of Fine Arts (the precursor to the San Francisco Art Institute) and the San Francisco Museum of Art were tantalizingly close to making genuine commitments to the medium. Adams saw this moment as an opportunity to unite both his centers of activity into one, and to make Northern California a truly important venue for his own field. During the war Nancy Newhall gamely took her husband's place as acting curator of photography at the Museum of Modern Art in New York, but when Beaumont returned, he found the conditions there dramatically altered, and he left the department, which was by this time under the influence of Edward Steichen. Adams saw the uncertain future of his closest friends as an opportunity to bring them out West. He attempted to cobble together several part-time opportunities for the couple in the Bay Area, since no single institution seemed capable of offering them meaningful full-time positions.

In response to his lobbying effort, Adams received a letter from Grace Morley on December 28, 1945: "As you know," she stated, "we have long been interested in photography, but have been pretty well stopped by conditions during the war

period. It is one of the things I would like to see worked out soundly here, but it must really be sound." Yet, Morley could not make a concrete proposal. She was still concerned about what to do with the pictorialists and was anxious to avoid competing with local teaching institutions. Morley concluded her letter by lamenting, "There is so much to do, and of course, as a small museum we are handicapped in not being able to have on our staff enough specialists or sufficiently distinguished specialists to do the kind of work we believe in."[11] This letter followed several months of rather intense correspondence between Morley, Adams, and the Museum of Modern Art, in which she tried but failed to obtain Adams' exhibition *Born Free and Equal* (1944), photographs of the Japanese internment camp at Manzanar.

The California School of Fine Arts was more fortunate. On November 1, 1945, the Columbia Foundation (of the Haas family) donated funds to establish a department of photography, stating specifically that it was to be under Adams' direction.[12] Adams had long been interested in this project, and had worked hard at persuading the school to take photography seriously. By this time, however, it had become clear that the Newhalls would not make a radical move west, and Adams must have been drained by his efforts. After designing and implementing the first year of the program, Adams recommended that Newhall's former assistant, Minor White, take charge of the department and left to pursue work for his own Guggenheim grant.

Adams' ambitions for the SFMA did bear fruit despite his obvious, but always unstated, frustrations. Shortly after Beaumont Newhall resigned from the Museum of Modern Art in March of 1946, Nancy Newhall "put in a good word for Grace Morley" to Georgia O'Keeffe as the latter set about dispersing the Stieglitz collection.[13] San Francisco would finally begin a serious photography collection, for on June 17 Morley wrote O'Keeffe:

I was advised to tell you that though we have at present no large collection of photographs, we have the beginning of a good one and are planning an eventual development of a photographic department, more modest, naturally than that of the Museum of Modern Art but along the same lines. Should there, therefore, be an opportunity of securing at least typical examples of Alfred Stieglitz' periods, we should be very much interested indeed.[14]

In 1952, sixty-seven Stieglitz prints entered the collection. Though they were not the Museum's first photography acquisitions— the first print to be catalogued was actually a portrait of José Clemente Orozco by Adams—they were its first substantive body of historically important photographic work.[15]

Morley and Adams continued their respectful relationship. He was given solo exhibitions at the SFMA in 1949 (*Photographs by Ansel Adams*) and 1951 (*Portfolio II, The National Parks and Monuments*), and was included in other group shows until Morley's departure in 1958. Their later correspondence, although not frequent, remained consistent. Morley would repeatedly confirm her intent to devote more attention to photography at the Museum but also complain of the lack of resources and public interest. Meanwhile, Adams always remained encouraging, helpful, and full of suggestions. After Edward Weston's death, Morley solicited Adams' advice in finding a Weston show and prints to add to the collection.[16] By 1957 she was able to report that "two people on our staff now are deeply interested in photography: John Humphrey, whom you know, and John Baxter. It just may work out that through them and such a committee as you suggest, we can gradually work in the direction you indicate."[17] John Humphrey had been a staff member at the Museum since 1935 and gradually assumed the role of curator of photography.

In 1960 the de Young Museum presented a show, *Photography at Mid-Century*, which had been organized by Beaumont Newhall at the George Eastman House in Rochester. Adams' disappointment with the installation led to a meeting with the de Young curator and eventually to a renewed relationship with that museum. In 1963 the de Young hosted his retrospective show, *The Eloquent Light*. But this meeting also elicited a testy evaluation of the local attitudes to photography under which Adams labored, and where he and his friends located their own—and photography's— higher claims:

> …we don't have a single critic who understands photography, and we never have had a museum or a gallery that knew the subtleties of the medium, and who knew really how to display it. I said the whole thing was set up on the Family of Man concept, and that all Mr. Frankenstein can think of is more or less appraising photography for its subject content, because he can't find in straight creative photography any correlation with abstract painting, about which he probably knows considerable.[18] I told her [the de Young curator] that many of the contemporary museum people are scared to death of photography, and veered off from the kind of creative photography we know as the equivalent, or any photography that dared to approach a "pictorial" aspect. The tendency, therefore, is to lean on that type of photography which is of the documentary or journalistic character, and which is really the glorification of the subject.[19]

In 1972, when Adams was seventy years old, he attended a luncheon hosted by Elise Haas, the mother-in-law of Evelyn Haas and a longtime trustee of the SFMA. There was some discussion about what Adams could do for the Museum. He responded afterward with a note to Mrs. Haas describing the value of his collection (of both his own work and others') and his family's needs. He then added:

> I think your idea of making the S.F.M.A. the photography center of the West is admirable. I will do everything I can to assist in this great objective. John Humphrey has done a very fine job. I can see, however, that there is need for a highly trained expert in the field to develop a Department of Photography and make an appropriate balance between acquisitions (the Collection) and the exhibitions (and publications).

Adams concluded:

> The West is, in many ways, the center of modern creative work in photography. Some would dispute this, claiming that New York and Boston should be considered first. In the east there is emphasis on the social aspects of the medium; out here there is a fine balance between the social emphasis on the natural scene and on the abstract and experimental.[20]

As for the San Francisco Museum of Art, it was in the end John Humphrey, whom Adams knew and had acknowledged in his letter to Mrs. Haas, who managed—in his quiet way and without demonstrable support—to fashion the beginnings of a first-rate photography collection for the institution. After acquiring the Stieglitz prints, the Museum purchased thirty photographs by Edward Weston from his son, Brett, in 1962, and the following year the collection was further enhanced by the gift of the Henry Swift Collection, comprising major works from the Group f/64. The Theo Jung Collection, strong in examples of documentary photography, entered the Museum in 1964, and this gift inspired others so that, when Humphrey was replaced by Van Deren

Coke, who was hired as director of photography in 1980, four years before Adams' death, the Museum had achieved a credible national presence for its photography collection and its increasingly ambitious exhibition program.

Ansel Adams was a gregarious figure and, unlike his close friend Edward Weston, could not be satisfied with a quiet, even priestly life devoted entirely to making art. His was a more hyperactive personality, one that felt a constant need for human relationships—the sheer quantity of his personal correspondence attests to this vital outgoing nature. With his intelligence and energy, he served as spokesman for the serious presentation of photography in the West, and his encouraging presence certainly contributed to its sustained artistic achievement. In later years he also became a formidable presence in the conservation field as well as a cultural ambassador for photography, promoting interest in the medium through his highly popular photography workshops and the many careful books he produced on photographic technique and criticism, as well as his own work. At his death he was the most widely recognized photographer in the United States.

NOTES

1. Ansel Adams, *Letters and Images 1916–1984*, edited by Mary Street Alinder and Andrea Gray Stillman, with a foreword by Wallace Stegner (Boston: New York Graphic Society, 1988), p. 51. Like Stieglitz, Adams also planned to show contemporary painting in his gallery.
2. Ibid., pp. 57–58.
3. See Ansel Adams on photography at the de Young in *The Fortnightly*, vol. 1, no. 5 (6 Nov. 1931), p. 25, on Atget and Weston; vol. 1, no. 7 (4 Dec. 1931), p. 25, and vol. 1, no. 8 (18 Dec. 1931), pp. 21–22, on Weston; vol. 1, no. 12 (12 Feb. 1932), p. 26, on Cunningham; and an unpublished two-page manuscript on Van Dyke, Moholy-Nagy, and an architectural show dated 17 May 1932 (*The Fortnightly* ceased publication on 6 May 1932). Rollins was shortly relieved of his directorship of the de Young—in part, because of his interest in exhibiting photography.
4. From his application to the John Simon Guggenheim Memorial Foundation, 1935, written in late 1934. Ansel Adams Archive, Center for Creative Photography, University of Arizona, Tucson.
5. In response to the interest generated in modern art, the San Francisco Art Association began in 1916 to present exhibitions in the Palace of Fine Arts, a building left over from the exposition. Called the San Francisco Museum of Art, this organization all but disappeared in the mid-1920s and was later reconstituted in the War Memorial Veterans Building.
6. Morley received B.A. and M.A. degrees from the University of California, Berkeley, and a Ph.D. in French literature and philosophy from the Sorbonne, and had attended a museum training seminar at Harvard University during a summer session.
7. Adams, *Letters*, p. 119.
8. See the correspondence between Morley and Evelyn Haas, and the letter to Newhall, all 1941, in the Grace McCann Morley files at the San Francisco Museum of Modern Art.
9. See Ansel Adams to Grace McCann Morley, 11 July 1943, and her response, 3 Aug. 1943, in the Grace McCann Morley files at the San Francisco Museum of Modern Art.
10. Grace McCann Morley to Louis J. Spuller Jr., 19 Jan. 1940, in the Grace McCann Morley files at the San Francisco Museum of Modern Art.
11. Grace McCann Morley to Ansel Adams, 28 Dec. 1945, in the Grace McCann Morley files at the San Francisco Museum of Modern Art.
12. See the application for the department to the Columbia Foundation, representing Adams' ideas and probably essentially written by him. Adams had specifically based the program on the structure of the music conservatory. The application to the Columbia Foundation from the San Francisco Art Association, 22 Oct. 1945.
13. Nancy Newhall to Ansel Adams, 9 Sept. 1946, Ansel Adams Archive, Center for Creative Photography, University of Arizona, Tucson.
14. Grace McCann Morley to Georiga O'Keeffe, 17 June 1947, in the Grace McCann Morley files at the San Francisco Museum of Modern Art.
15. See the correspondence between Morley and Adams, 1951–52, in the Grace McCann Morley files at the San Francisco Museum of Modern Art.
16. Weston's work finally came to the SFMA in 1962 by gift of his son, Brett Weston.
17. Grace McCann Morley to Ansel Adams, 14 May 1957, Ansel Adams Archive, Center for Creative Photography, University of Arizona, Tucson.
18. Alfred Frankenstein was art critic for the *San Francisco Chronicle* and the author of the first monograph on the nineteenth-century American still life painter William Harnett.
19. Ansel Adams to Beaumont Newhall, 13 Aug. 1960, Library, Getty Research Institute, Los Angeles.
20. Ansel Adams to Elise Haas, 19 Nov. 1972.

ANSEL ADAMS AT 100

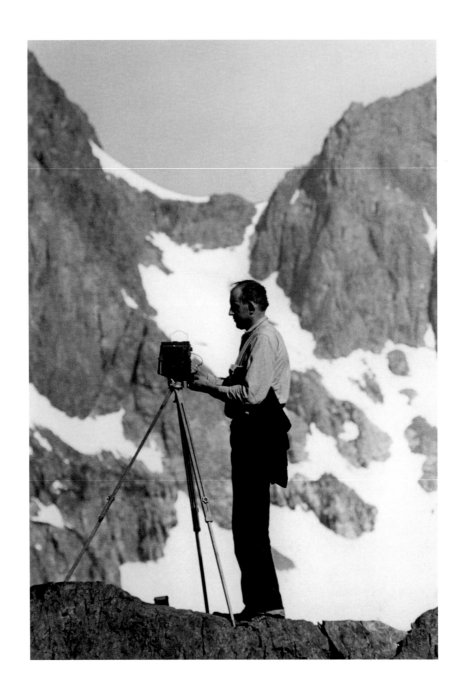

ANSEL ADAMS AT 100

John Szarkowski

In 1922 the photographer Edward Weston (then thirty-six years old, with pockets full of ribbons attesting to his status as an art photographer) wrote that straight photography could not satisfactorily deal with the subject of landscape "for the obvious reason that nature unadulterated and unimproved by man— is simply chaos."[1]

Little by little, beginning with details and working slowly outward to the broad vista, Weston learned to photograph the landscape brilliantly, but the fact does not disprove his original intuition about the nature of nature. The question is this: Does the order that we find in a satisfactory landscape picture exist objectively in the subject matter, like gold in the gravel bed? Or is it merely an invention—the function of willful selection?

If the natural world can be thought of as a kind of artifact, in which evolution has produced something resembling logical structure, then the job of the landscape artist might be to discover that figure in the carpet—"the string the pearls were strung on," as Henry James put it in his story.

Henry's older brother, William, doubted that any such structure exists, except as we invent it. "When we view the world with no definite theological bias one way or the other, one sees that order and disorder, as we now recognize them, are purely human inventions. We are interested in certain types of arrangement, useful, aesthetic, or moral—so interested that whenever we find them realized, the fact emphatically rivets our attention. The result is that we work over the contents of the world selectively. It is overflowing with disorderly arrangements from our point of view, but order is the only thing we care for and look at, and by choosing, one can always find some sort of orderly arrangement in the midst of any chaos….Whatever of value, interest, or meaning our respective worlds may appear endued with are thus pure gifts of the

FIGURE 1. Rondal Partridge. *Ansel Adams in the High Sierra*, ca. 1935. Center for Creative Photography, the University of Arizona.

spectator's mind."[2] If this is the case, then artists of the wild landscape might be thought of as a community of inventors who, generation by generation, produce and revise an evolving sketch of order out of the great farrago.

During the quarter century between the late twenties and the early fifties, the photographer Ansel Adams made tens of thousands of negatives, and completed many hundreds of photographs, of the American landscape. Most of them were made in the continental United States, west of the foothills of the Rocky Mountains. Most of that majority were probably made in his home state of California, and perhaps most of those in Yosemite Valley, or in the High Sierra that guarded the Valley on the east. Yosemite and the High Sierra constituted the place he knew and loved best. Perhaps it was the *thing* he knew and loved best.

Adams' pictures have revised our sense of what we mean when we say *landscape*. Even those who are more at home in the mysterious swamps or in the incomprehensible boreal forests, or even those who are more at home in great cities or in a handkerchief-size garden at the rear of the eighth-acre town plot—even many of these have been moved and enlarged by Adams' pictures, which demonstrate that even in the great theatrical diorama of Yosemite the mountains are no more miraculous than a few blades of grass floating on good water. His pictures have enlarged our visceral knowledge of things that we do not understand.

Ansel Adams was born in San Francisco in 1902, a scant one hundred and thirty years after the place had been named after Saint Francis of Assisi, who spoke to birds and was not interested in gold. After seventy-five years of management under that philosophy (not always rigorously applied), the town had achieved a population of nine hundred souls. At that point, in 1848—as part of the treaty that settled the Mexican War—Mexico ceded California to the United States. In the same year, gold was discovered at Sutter's Creek; two years later San Francisco and its outlying territories became one of the United States of America, under the name of California. The new state encompassed some ninety thousand people (not counting the natives, of course), consisting of a minority of miners, plus the Hispanic Californians, and the new merchants, mule skinners, moneylenders, ministers, saloonkeepers, assayers, prostitutes, and lawyers who served the material and spiritual needs of the new population.

This is to say that Adams was born into a world that had first been visited by the serious attentions of modern Western culture in the very recent past. The San Francisco of Adams' childhood was still a frontier city, replete with the quick fortunes, quick bankruptcies, and fast dealing associated with such places.

A quarter century later a new vein of gold was struck in the southern end of the state when the movie industry concentrated itself—because of cheap land and constant sunlight—in a suburb of the small city of Los Angeles. Before long Los Angeles had grown so vigorously that San Francisco could assume the posture of an old-world center of traditional culture—standing to Los Angeles, roughly speaking, as Boston did to New York. But that sophistry was still in the future. When Adams was born, San Francisco was a frontier town.

In his autobiography Adams says that as a child he was what would now be called hyperactive, and the diagnosis seems modest enough. He also says that his mental state was precarious and that at the age of ten he experienced periods of unexplained weeping, for which the doctor prescribed two hours in bed in a darkened room every afternoon. Adams

attended, unsuccessfully, a succession of schools, where he found it difficult even to remain seated at his desk. One day when he was twelve, it came to him that his situation was ludicrous and intolerable. "I burst into raucous peals of uncontrolled laughter; I could not stop. The class was first amused, then scared. I stood up, pointing at the teacher, and shrieked my scorn, hardly taking breath in between my howling paroxysms....[I] remained under house arrest for a week until my patient father concluded that my entry into yet another school would be useless."[3]

When Adams was twelve, his formal schooling was suspended, and as events proved, finished. His father tutored him in French and algebra, insisted that he read the classics of English literature, and sent him to a minister who taught him a little Greek and who earned the child's undying scorn by telling him that God had created the world in October 4004 B.C.

Whatever handicaps Adams might have been born with were surely exacerbated by his life at home, which would seem to have been a genteel kind of hell. He grew up in a large house beyond the edge of town, with a disheartened father, an embittered mother, and her nervously dependent sister. When Adams was born, his family was prosperous, although the considerable fortune of Adams' paternal grandfather was already considerably diminished. Before the child reached teen age, the family was in financial trouble. Through bad luck, or incompetence, or the chicanery of his partners, or some combination of the three, Charles Adams (Ansel's father) had lost what was left of the family business, and he spent the last half of his life struggling to remain in the middle class. His wife and her sister seemed not quite able to forgive him for having deprived them of the security and status that had come to seem their natural right. (As a young man Ansel invited the poet Ella Young to dinner with him and his family, and after-

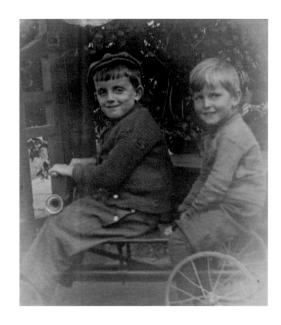

FIGURE 2. Ansel Adams and friend, ca. 1906 (photographer unknown). Anne Adams Helms.

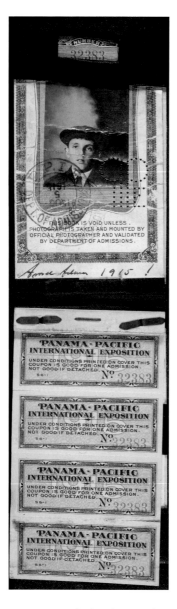

FIGURE 3. Ansel Adams' pass to the Panama-Pacific International Exhibition, 1915. Center for Creative Photography, the University of Arizona.

ward, as he walked her to the gate, she told him that the words of his mother and his aunt were like little hammers of pain.[4]

Philo Blinn said that those who are accustomed to money, and become poor, make the poorest kind of poor,[5] but Charles Adams seems to have managed his decline with considerable grace, in spite of the poisonous atmosphere in his own house. Perhaps in compensation for the shortcomings of this world, he became a noted amateur astronomer and in 1931 was made a Fellow of the American Association for the Advancement of Science, in recognition of his service to the Astronomical Society of the Pacific.[6] It seems typical of Charles Adams that when confronted with a child who simply could not manage school, he gave that child a yearlong pass to the San Francisco World's Fair of 1915 (the Panama-Pacific International Exposition). Adams remembered that he visited the fair almost daily. He also found a friend there—one Thomas Mooney— who managed the Underwood Typewriter exhibit (a diorama on the history of writing) and explained the secrets of the very high-tech mechanism to the thirteen-year-old Adams, swearing him to delicious secrecy. But the good memories of that friendship were destroyed two years later when Mooney was sentenced to prison for complicity in the Preparedness Day bombing of 1916.

It is tempting to play psychoanalyst, and guess that Charles Adams' immersion in astronomy and its endless alternative worlds was the reflection of a dissatisfaction with the one he lived on. A similar strain of otherworldliness—sometimes approaching estrangement—surfaced periodically in his son, in whom it alternated with moods of manic gregariousness. Beneath the compulsory optimism and misty pantheism with which California then faced the larger world, such dark moods were not uncommon. Adams' friend and neighbor Robinson Jeffers, in his poem "New Mexico Mountain," wrote that

civilization was a transient sickness, and Adams sometimes seemed to agree.

In 1916 the Adams family visited Yosemite Valley, sixty-five years after a European had first laid eyes upon it and eleven years after John Muir had taken President Theodore Roosevelt there on a four-day camping trip, trying, with partial success, to bring the great man into his light. In 1916 it was a two-day trip from San Francisco to Camp Curry on the floor of the Valley, where the Adams family took its place among the ten thousand visitors that the camp accommodated during the short tourist season. Ansel had never seen anything so wonderful, and he blossomed physically and socially. He climbed the trails with abandon, and wrote his Aunt Mary, back in San Francisco, that "yesterday I went up to Sierra Point and enjoyed lying on my chest and looking over the edge—about fifteen hundred feet down—perpendicular."[7] He also reported that he had already made thirty photographs with his new Kodak Brownie—his first camera. There was nothing very unusual in 1916 about a fourteen-year-old child of a middle-class family making snapshots on the family vacation. George Eastman and his competitors had begun to make photography universally available a quarter century earlier, and by 1916 only poor people did not have cameras. Nor did the first snaps of the young Adams indicate any special genius, although one might say that they were neatly framed.

The snaps were memory aids; it was the memory that was the essential thing. Yosemite took hold of the child, and for the rest of his life he returned as frequently as he could. When he was away, Yosemite was never far from his thoughts. We might think of it as the source of his sanity and his strength.

When Adams was forty-two he wrote his father to ask biographical questions about the family's history, but also, more remarkably, to ask questions about his own childhood.

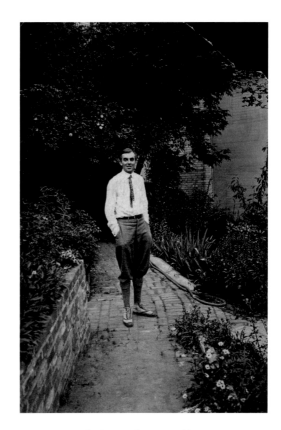

FIGURE 4. Ansel Adams at his parents' house, San Francisco, ca. 1922 (photographer unknown). Anne Adams Helms.

FIGURE 5. Ansel Adams, *Henry Cowell*, ca. 1930.
Special Collections Department, F. W. Olin Library,
Mills College.

One might have thought he would have remembered when he attended various schools, when he began studying music, etc., but he asked "What was [his] school history?" as though he were researching some ancient ancestor. His father skillfully avoided a direct answer to his son's question about his school record, concentrating instead on what Ansel had learned, and from whom. The brightest, most confident part of the father's report had to do with Ansel's musical talent: he had taught himself a good deal about the piano before he was assigned to his first teacher, who was apparently followed in fairly quick succession by other, presumably more sophisticated pedagogues. In 1914 Adams' father had written to his mother and his sister: "My Dear Mother and Cassie: Ansel has developed quite a taste for music lately. He started a few months ago to play on the piano and, heaven knows where it comes from, but he can read almost anything put before him at sight. Four months ago he didn't know a note and of course has never taken lessons so I can't quite understand it. Mrs. Cowell, a singer, who lives here in West Clay Park, has had Ansel play for her & says he surely has genius, and her step-son, who is a sort of musical wonder and who, though only 16 years old is giving public concerts on the piano and who composes orchestra music, has taken a great interest in Ansel and is going to give him lessons."[8] By the time Adams was twenty-one, he considered himself a professional musician and was committed to the goal of being a concert pianist.

In 1925 the penniless Adams bought a Mason & Hamlin piano for $6,700, the cost of ten top-drawer Ford cars.[9] He described it to Virginia Best, his future wife, as "the finest instrument that money can buy." To meet the down payment, he sold a lot that had been given to him by an uncle; the remainder was paid over the next five years, at seventy-five dollars a month, by Adams and his father. In the letter to Virginia, Adams listed

seven conclusions (identified by Roman numerals) that he had recently come to, which were clearly to be read as reasons why he would not be marrying anyone in the foreseeable future. Conclusion V stated that "I know that God has bestowed upon me a great gift, which in itself is a most tremendous responsibility. To neglect it would be criminal indeed."[10] When a little older, he would not have revealed in so unguarded a way the fierceness of his ambition, but there is no reason to believe that he ever changed his mind, even in his old age, when he had learned to wear the mantle of humility as though it were his own skin.

Later, long after the fact, Adams recollected that he had not decided until 1930 to devote his life to photography rather than music. His mother hoped that she had misunderstood, and said that surely he did not want to be only a photographer.[11] There was of course much to be said for her position, which she presumably would have held with greater tenacity had she known the great San Francisco landscape photographer Carleton Watkins, who in 1916 (while young Ansel was making his first snapshots of Yosemite) died penniless and forgotten in the Napa State Hospital for the Insane.

Adams' great good friend Beaumont Newhall was surely confused when he remembered (much later, and late in his own life) that Adams was "studying to be a concert pianist" in the early forties.[12] It is clear, however, that Adams in those years still spent a good deal of time practicing—and performing, for friends, or acquaintances, or potential acquaintances, at any party that included a decent piano. As late as 1945 he still thought enough of his playing to have a record produced of his performances of Chopin and Beethoven. But by the fifties his hands were becoming progressively crippled by arthritis and he would have no longer been tempted to hope that he might attain the highest professional standards.

There can be no doubt (or little doubt) concerning Adams' belief in his talent, nor of his high ambition. But it must also be admitted that every considerable American town harbored a young pianist of confidence and high talent, many of whom could play marvelously well. It seems clear that Adams was a splendid musician, but it would probably be a mistake to assume that the piano lost a potential great master when Adams decided that he would rather be a photographer.

In fact, that might not be quite the correct formulation. From Adams' own letters one might make the case that he gave up the piano not for photography but for Yosemite. Early in 1927 he wrote to Virginia Best, who lived in the Park with her father and whom he would marry ten months later: "Music is wonderful—but the musical world is the bunk!…I find myself looking back on the Golden Days in Yosemite with supreme envy. I think I came closer to really living then than in any other time of my life, because I was closer to essential things."[13]

This cry for help is double-edged. Adams is expressing both a revulsion at "the petty doings—the pose and insincerity" of the musical world and a longing for the elemental world of Yosemite, and it is not clear whether the push or the pull was the stronger force. In either case, Yosemite Valley was not the ideal place to advance one's career as a concert pianist. On the other hand, the fact that Virginia's father owned a piano might have helped Adams postpone his decision.

Six weeks later (with three thousand dollars still to pay on the Mason & Hamlin) Adams wrote Virginia again to say (in part) that "my photographs have now reached a stage where they are worthy of the world's critical examination."[14]

We should perhaps not try too hard to make logical sense out of letters between young lovers. When Adams made this boast to Virginia, he was already committed to produce a portfolio

FIGURE 6. Ansel Adams. *Virginia Adams and Albert Bender*, ca. 1930. Center for Creative Photography, the University of Arizona.

of prints that had been proposed and guaranteed by his new benefactor Albert Bender, an insurance broker and philanthropist with a deep commitment to San Francisco's world of arts and letters. Bender liked Adams' photographs, and proposed that he produce one hundred portfolios of eighteen prints, each portfolio to sell for fifty dollars. On the morning that the project was born, Bender bought ten portfolios in advance and handed Adams his check for five hundred dollars. While Adams sat "electrified," Bender sold by phone more than half the edition, even before all of the negatives had been made.[15] One might say that it was Bender, not Adams, who made the decision that Adams' pictures were ready for the world's critical examination.

The portfolio was called—at the insistence of the publisher—*Parmelian Prints of the High Sierras*. The term *Parmelian* was a synthetic and meaningless word, made up of bits and pieces of various high-toned real words, perhaps including *Parthenon, Parnassus, amelioration,* and *Peleas* and *Melisand*. The portfolio's title did make it clear that these were not ordinary photographs. To some prospective purchasers, it may have obscured the fact that they were photographs at all. The invented term had something of the Madison Avenue scam about it, and it was a mild embarrassment to Adams for the rest of his life, but perhaps not so embarrassing as the unwonted s on the end of *Sierra*.

The eighteen pictures selected for the portfolio included three or four that might still be included in a selection of Adams' important work, but the Adams who produced the *Parmelian* portfolio was certainly not yet Adams at his full power. Nevertheless, he was learning very rapidly. His development is documented with extraordinary clarity in the proof albums of his pictures made on the Sierra Club Outings. Beginning in 1925, he made albums of photographs on these

mass camping trips for not fewer than nine years between that year and 1936.[16] These thick albums of prints were deposited at the San Francisco office of the club, and from them members could order prints, at (in 1927) one dollar each on white or buff stock, or $2.50 on the fancier "parchment" stock in a paper folder. A less compulsive, more reasonable worker than Adams would surely have edited his summer's take down to (perhaps) his thirty or forty best, which could presumably still have covered all the memorable peaks, canyons, and traverses, and which would have greatly simplified Adams' printing problem. But luckily for photo historians, he seems to have included in his sample books every picture that was not a clear technical failure. Thus we have in these albums what is perhaps a unique record of a major photographer in the process of learning his craft: in the late twenties we can see him trying one framing and then another, then trying a wider view, and then a narrower one, then moving to a slightly new vantage point, from which he would again work his way through the promising possibilities, which changed as the light changed.

By 1928 one can see a new economy and sureness come into Adams' work. The peaks and ice fields and terrains of rubble begin to be—in addition to geological events—parts of pictorial patterns that possess an independent authority: designs that seem to recapitulate in visual terms the ancient history of the place.

The process by which an artist learns and grows is mysterious and perhaps ineffable, which does not mean that artists and critics will stop trying to explain when and from where the new knowledge comes. It is not quite satisfying to be told that growth comes in tiny increments, during long days of plain work. We prefer to think of it arriving as a series of epiphanies, each opening a door onto a world that had previously been hidden.

Adams described several such moments. One came in 1927 as Adams stood on a granite shelf four thousand feet above the floor of Yosemite Valley, facing the motif that he later titled *Monolith, the Face of Half Dome*. With a single plate left in his camera bag, it came to Adams that the finished print might more closely match his sense of the emotional power of the experience if he revised the tonal relationships of the picture by exposing his negative through a red filter, which would deepen the tone of the sky almost to black.[17] Adams remembered the occasion because he had, for the first time, consciously applied a specific technical solution to an aesthetic problem. He used the red filter not by rote, or because dark skies were good, but because a dark sky was necessary for the picture he envisioned. Nevertheless, an epiphany that depends on the intercession of a red filter is not everything that one might hope for. In fact, this first conscious memory of what Adams came to call previsualization might be considered simply as another incremental piece of technical understanding. If the idea of previsualization had been truly essential to his work, then his earlier pictures would by definition have been failures, and it is clear that he continued to the end of his life to consider a substantial number of his earlier pictures to be among his important work.

The *Monolith* story might be more useful to an understanding of Adams' development if we consider it as one moment during a longer and broader change in Adams' view of photographic form. One might say that until the mid-thirties Adams' landscape work is conceived largely in graphic terms—as pattern—and is dependent primarily on choice of vantage point and framing; as that decade advanced, the coherence of Adams' pictures is increasingly dependent on the perfection of the tonal scale, which binds the picture together almost in a membrane of light.

(continued on page 30)

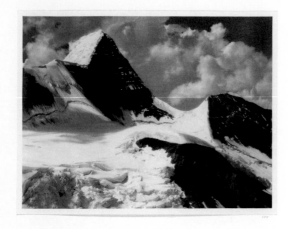

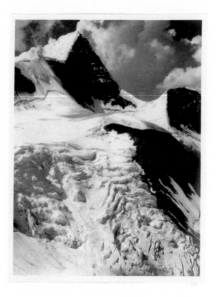

Mount Robson from Resplendent

FIGURE 7. Ansel Adams. *Mount Robson from Mount Resplendent*. Pictures 155, 156, 157, and 158 from albums of the Sierra Club Outing of 1928. The Bancroft Library Pictorial Collection, University of California, Berkeley.

THE SIERRA CLUB ALBUMS

In the late twenties a new authority enters Adams' work. Prior to that time many (not all) of his mountain photographs seem to have been made as souvenirs of memorable climbs—produced in a spirit similar to that in which a big-game hunter collects specimen heads. But in the latter part of the decade the work consistently demonstrates a heightened intensity of purpose, and a clear under-standing of the difference between geological reportage and picture-making.

The best surviving record of his learning process during these crucial years exists in the photo albums of the Sierra Club Outings. By 1928 the albums show Adams working his way, systematically and stylishly, through the formal possibilities of straight photography.

The four consecutive versions of Mount Robson from Mount Resplendent (figure 7), from the 1928 albums were made from essentially (perhaps exactly) the

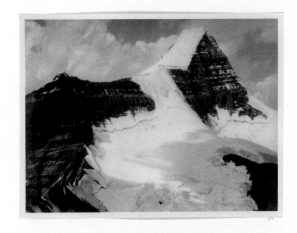

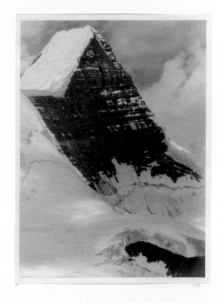

same vantage point. There is no reason to assume that the negative numbers describe the order in which the exposures were made, nor can it be demonstrated that the two made in bright sunlight (numbers 155 and 156) were made on the same day as those made under a thin overcast (numbers 157 and 158), although Adams does note in his Autobiography that the light and weather in the Canadian Rockies changed often and quickly. The four pictures were made with lenses of three or four different focal lengths, number 156 being made with the shortest lens and number 158 with the longest. The intermediate sizes of the projected images of numbers 155 and 157 are almost but not quite the same; it seems unlikely that Adams would have carried by pack train two lenses so close in focal length, which might suggest that number 157 was made from a slightly closer vantage point, but on virtually the same axis as the other pictures.

The point to study here is the way in which the framing of each picture is radically changed in each case, to take advantage of the new potentials provided

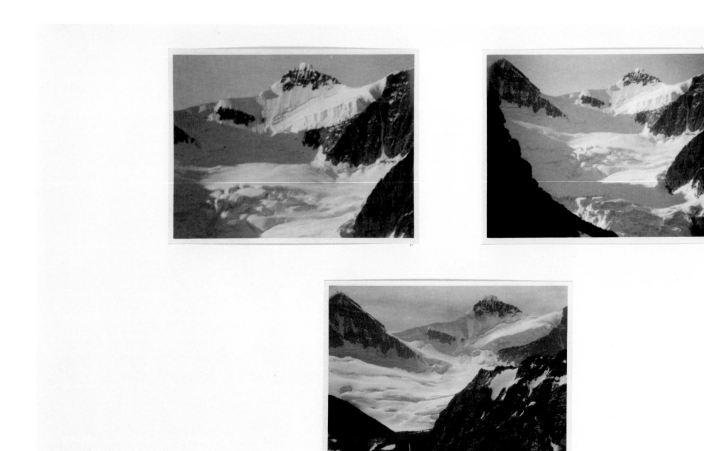

FIGURE 8. Ansel Adams. *McDonell Peak and Bennington Glacier*. Pictures 87, 88, and 89 from albums of the Sierra Club Outing of 1928. The Bancroft Library Pictorial Collection, University of California, Berkeley.

by changes in the cone of vision and changes in the character of the light.

Of the three versions of McDonell Peak and Bennington Glacier (figure 8), also from the 1928 albums, numbers 87 and 88 were made from the same vantage point and (according to the shadows) very nearly at the same moment. Number 88 was made with a lens of substantially shorter focal length. Because of the inclusion of the dark landmass in the lower left corner, the picture has been printed substantially lighter overall. Since Bennington Glacier lies north of McDonell Peak, we

know that Adams' camera is pointed south and that the sun is moving from left to right. Hence exposure 89 was made later in the day, and more directly into the sun. It is also made from a vantage point that has moved to the left and closer (or alternatively, to the left and with a lens of a focal length intermediate between those of exposures 87 and 88). The change in the light and the vantage point produce different design possibilities. One might say that exposure 87 is composed of dark shapes on a light ground, and that exposure 89 has reversed the scheme.

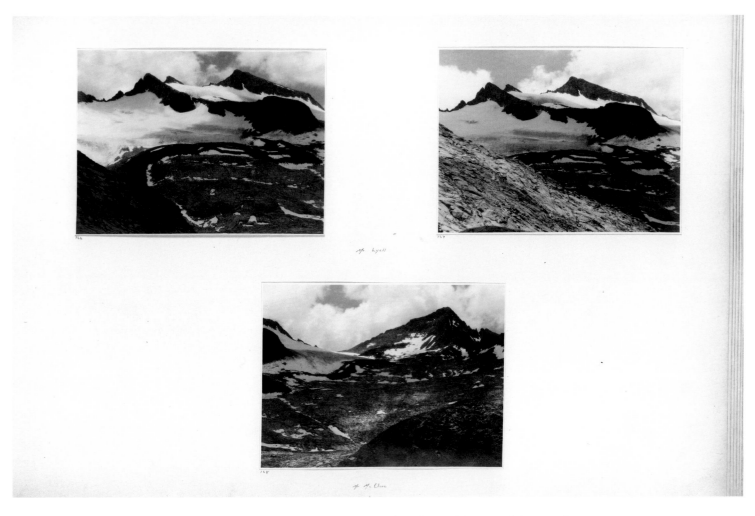

FIGURE 9. Ansel Adams. *Mount Lyell and Mount Maclure, Yosemite.* Pictures 166, 167, and 168 from albums of the Sierra Club Outing of 1929. The Bancroft Library Pictorial Collection, University of California, Berkeley.

In Mount Lyell and Mount Maclure, Yosemite *(figure 9), from the 1929 albums, the light and the cone of vision (focal length) remain constant, but the vantage point and framing change. (The forms at the upper right corner of exposures 166 and 167 reappear in the upper left corner of exposure 168.) It is interesting that Adams seems to have preferred number 166—the only one of the three exposures known to have survived as a finished print. (See plate 6.) It is visually the flattest of the three, perhaps because of the bisected oval shape that the drifted snow forms on the dark ground. The tendency toward graphic, powerfully two-dimensional designs is typical of Adams' most original work during the twenties and much of the thirties, and this quality is heightened by his frequent use, in those years, of lenses of long focal length, which have the effect of collapsing deep space into pattern.*

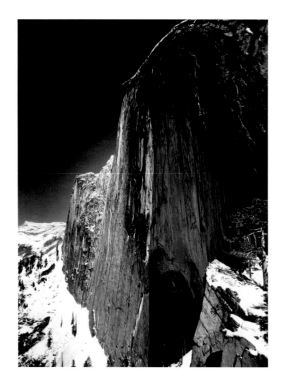

FIGURE 10. Ansel Adams. *Monolith, the Face of Half Dome, Yosemite National Park*, 1927. The Ansel Adams Publishing Rights Trust.

It is of course true that any straight photograph depends on the description of both shape and texture (surface), but the distinction between the two is nevertheless valid and useful. One might test the proposition by chosing half a dozen of Adams' best landscapes from the years around 1930 and six more that are typical of his best work of ten years later, and reproduce all twelve pictures as postage stamps. The earlier pictures would surely be damaged, but their basic visual character would in most cases survive. The later pictures would often be aesthetically unintelligible.

A second occasion that seemed to represent for Adams a sudden leap into deeper sureness came when he met Paul Strand, in Taos, New Mexico, in 1930. Strand and Adams were both the guests of Mabel Dodge Luhan, probably then the most ambitious artistic *saloniste* between the Mississippi and the Sierra. Her most impressive long-term guests were doubtless D. H. and Frieda Lawrence, but there were others of considerable standing. Adams' reputation was still modest and local, but Strand was in the pond of ambitious photography a very big fish indeed. In 1917 Stieglitz had dedicated the last, double issue of his great periodical *Camera Work* to Strand's first mature work, and it seemed to many—almost surely including Strand—that Stieglitz had also awarded Strand the baton of leadership over that little cohort of photographers who had high artistic ambitions for their medium.

In 1930 Adams represented no threat to Strand's status, and he was received cordially by the famous man. In a textbook demonstration of male bonding, Strand (age forty) and Adams (twenty-eight) shot at tin cans from a moving car, while motoring from Taos to Santa Fe.[18] Strand also showed the younger man the negatives that he had made in New Mexico during the preceding weeks. Adams later remembered the experience as a revelation. The richness and completeness of

the tonal scale of Strand's negatives gave Adams a new sense of the potential of photographic beauty: "full, luminous shadows and strong high values in which subtle passages of tone were preserved."[19]

Adams saw on that day only Strand's negatives, and not his prints, and from Adams' point of view this might have been a good thing. Strand's prints tended to be deep-toned and glowing, like good old wood oiled and polished for generations. When Adams found his own photographic style, his prints were much brighter and livelier. It is well known that a photographic negative generally contains much more information than a print made from it, because the negative is a transparency, and thus can have a much longer scale of relative values, in exactly the same way that a stained-glass window has a longer scale of values than a painting on a panel or a canvas. A photographer chooses (with difficulty) which parts of his negative to reveal and which to submerge in the black and white ends of the paper print. Strand's characteristic tonality was perhaps defined by the quality of light that found its way down to a street that ran between tall buildings. Adams' tonality (until his later years) seems to have been based on the intensity of the light of the high mountains.

I have been unable to trace the red filter story and the Strand negative story to their earliest tellings, but it is my impression they were first recorded after Adams was famous enough to be asked questions concerning crucial influences, early lessons, objects of gratitude, etc. I am not aware that Adams—a prodigious writer of letters and magazine articles—recorded either experience at or near the time it occurred.

What seems a more spontaneous record of Adams' frame of mind during the period of his early serious efforts as a photographer is found in an undated fragment of writing that recalls

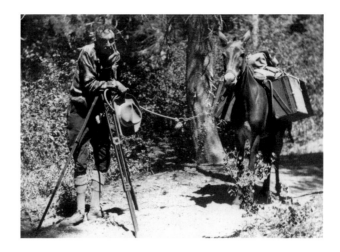

FIGURE 11. Ansel Adams with tripod and burro, ca. 1925 (photographer unknown). Center for Creative Photography, the University of Arizona.

an early extended trip into the high mountains, perhaps in 1923: "It was one of those mornings when the sunlight is burnished with a keen wind and long feathers of cloud move in a lofty sky. The silver light turned every blade of grass and every particle of sand into a luminous metallic splendor: there was nothing, however small, that did not clash in the bright wind, that did not send arrows of light through the glassy air. I was suddenly arrested in the long crunching path up the ridge by an exceedingly pointed awareness of the light. The moment I paused, the full impact of the mood was upon me. I saw more clearly than I have ever seen before or since the minute detail of the grasses, the clusters of sand shifting in the wind, the small flotsam of the forest, the motion of the high clouds streaming above the peaks. There are no words to convey the moods of those moments." [20]

How much he sounds like one of William James' ecstatic mystics! "When I went in the morning into the fields to work, the glory of God appeared in all his visible creation. I well remember we reaped oats, and how every straw and head of the oats seemed, as it were, arrayed in a kind of rainbow glory, or to glow, if I may so express it, in the glory of God." Or: "When I walk the fields, I am oppressed now and then with an innate feeling that everything I see has a meaning if I could but understand it. And this feeling of being surrounded with truths which I cannot grasp amounts to indescribable awe." [21]

One might guess that Adams spent the next quarter century trying to make a photograph that would give objective form to the sense of ineffable knowledge that on occasion, in his youth, inhabited him in the high mountains. Yosemite and the Sierra gave him not only his principal subject but the experience that provided the basis for a useful artistic idea. "The silver light turned every blade of grass and every particle of sand into a luminous metallic splendor."

The problem was to find the pattern of shapes, textures, and allusions that would stand as surrogate for a unique experience. It is probably correct to say that we can describe an idea more precisely than we can an experience. Perhaps experience itself cannot really be described, and to distract attention from this fact we retreat to metaphor, and say that the dawn came up like thunder or that the fog crept in on little cat's feet. The simplest and most common experience—the taste of water, let us say—has not yet been communicated in words or pictures, and most of us probably do not expect this breakthrough soon. Yet we might agree that our arts are at bottom an effort to do this—to give objective form not to our ideas but to our visceral knowledge.

In the pursuit of his private intuition, Adams made landscape photographs that are unlike those of any other photographer. The best of them possess a tenseness—an edgy, nervous vitality—that is only barely contained. One way to describe the distinctive character of Adams' landscapes might be to compare them with those of the other great American landscape photographer of the period—Adams' neighbor Edward Weston. Adams and Weston met at dinner at Albert Bender's in 1928; neither was at first glance enormously impressed by the other's work (which Bender had asked them to bring) or by the other's personality, but Weston was very much impressed by Adams' piano playing, and for him that excused anything. Gradually the two men came to respect, then admire, and finally love each other, in spite of the great difference between their work. It is instructive that the art world has tended to consider them as two varieties of a single species: California landscape photographer. But those who have bothered to look at their work surely recognize that their artistic intuitions were profoundly different.

One might say of Weston that if he had not been a great photographer, he might have been a great sculptor—preferably a stone carver, dealing with the solidity of the world—and, in contrast, that if Adams had not been a great photographer, he might have been a great calligrapher, dealing with lettering's flat curtain of ornament. Weston's pictures are about solid bodies, and Adams' are about the way that light dissolves weight. Weston's are about gravity, and Adams' are as disembodied as a movie screen—flickering in space like the aurora borealis.

The peculiar quality of Adams' vision is visible at its most extreme in pictures like *Clouds, Kings River Divide* (frontispiece), where conventional three-dimensional space is subverted by the exuberant piling on of every element of the picture, where the clouds and rocks and snow and sky all elbow and jostle one another to gain front place on the picture plane, where each element is articulated with perfect precision, and yet tied so tightly together that the scene is transcribed as one simple, joyous gesture—one mark on the sheet.

Much has been said and written about Adams' legendary technique—probably too much, for in fact it was no better than it needed to be to describe what he wanted to describe; often it was not good enough for that, as he repeatedly deplored. His technique had to be better than that of most photographers because his subjects required it. Photographing the air of Yosemite required a more sophisticated technique than was required to photograph its geology. Otherwise, Adams' insistence on precision would have been just showing off—fancy dancing with no partner, and none in view.

The fact that the friendship between the younger Adams and the older Weston took root, matured, and lasted must be considered a credit to them both: to Weston for his patience and his willingness to hold his tongue when Adams attempted

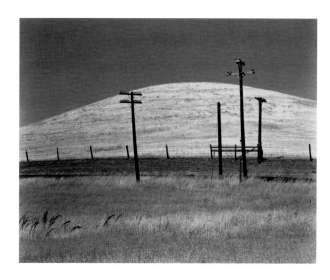

FIGURE 12. Edward Weston. *Hill and Poles, Solano County*, 1937. San Francisco Museum of Modern Art. © 1981 Center for Creative Photography, Arizona Board of Regents.

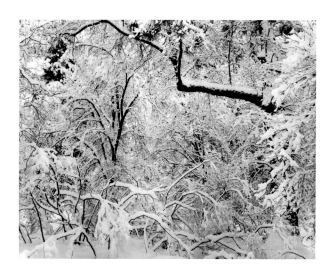

FIGURE 13. Ansel Adams. *Fresh Snow, Yosemite National Park*, ca. 1947. The Ansel Adams Publishing Rights Trust.

FIGURE 14. Ansel Adams. *Edward Weston*, n.d. The Ansel Adams Publishing Rights Trust.

FIGURE 15. Edward Weston. *Ansel Adams, Wildcat Hill*, 1942. Center for Creative Photography, the University of Arizona. © 1981 Center for Creative Photography, Arizona Board of Regents.

to solve the problems of art, or of Western civilization, in a late-night letter; and to Adams for his steadfast refusal to allow his great admiration for the older man to be corrupted by envy or by king-of-the-hill competitiveness. It is wonderful that the two men could recognize and appreciate each other's virtues, when they were so deeply different. It is only a genetic accident, of no critical significance but nevertheless fascinating, that in the portraits they made of each other Weston resembles a sitter of Hans Holbein—a solid, even stolid, earthbound boulder of a man, as sane as a milkmaid—whereas Weston's picture of Adams gives us someone rather like Savonarola, or a figure from a painting by Matthias Grünewald—an electric charge in the form of a man. Weston naturally gravitated downstream toward the beach, where he lived on tropical fruits; Adams was happiest in the high mountains, where he lived, for a while, on tinned hash, bourbon whiskey, and visions.

After a seven-year off-and-on courtship, Adams and Virginia Best were married precipitously on the second day of 1928, in her father's studio and souvenir shop in Yosemite Park, during the deep Sierra winter. Adams wore a blazer, plus fours, and sneakers, and Virginia her best available dress, which happened to be black. Soon after the marriage Adams announced himself as a photographer available for hire, and by early 1930 the couple moved into a new house and studio, next door to Adams' parents.

Neither marriage nor the obligations of business kept Adams at home. Since 1919 he had spent much of his summers in Yosemite or the Sierra, and from 1929 onward he seems to have served as photographer, equipment manager, and chief entertainer for the extraordinary mass camping trips that were called the Sierra Club Outings. During the winter he was

often in Santa Fe, working on current or potential projects. He missed getting home—if only by a day or two—for the birth of both his children: Michael in 1933, and Anne two years later. This peripatetic life did not lend itself either to an idyllic life at home or to the normal demands of a commercial studio.

As noted, by 1930 Adams had decided to make photography his career, and by about 1935 he was a semi-famous photographer. It is not altogether clear how he managed this, but it surely depended on Adams' famously phenomenal energy level, and on a physical constitution that periodically bent but did not break. During this five-year period Adams—besides meeting the demands of his business—had at least five one-man exhibitions, produced (with a homemade enlarger that used daylight as a light source) thirteen hundred original prints to be tipped into his book (with Mary Austin) on the Taos Pueblo, reviewed photography exhibitions for the short-lived San Francisco review *The Fortnightly*, and wrote articles on photographic technique for the periodical *Camera Craft*; in addition to spending much of each summer dealing with the Sierra Club trips, he also spent part of each winter making prints for the members, at prices that even then were extremely modest. He opened and briefly ran a photography gallery; he wrote the first book that was his alone, the very influential *Making a Photograph*; and he studied. Adams, the hopeless student who completed his formal education with an eighth-grade diploma negotiated by his father, seemed by the mid-thirties to understand more about the theoretical basis of practical photographic technique than any other working photographer, and he was willing—eager!—to share the fruits of that understanding with anyone who would listen.

The name that Adams had made for himself by the mid-thirties was probably based largely on the articles that he wrote first for *Camera Craft*, and subsequently for other popular magazines. His exhibition (in late 1936) in Alfred Stieglitz's gallery An American Place had surely impressed that tiny part of the population that followed photography's most ambitious artistic efforts, but in terms of the broad photography public, fame was bestowed by the popular magazines. Adams' *Camera Craft* articles were doubtless also the basis for the commission (from Studio Publications) to write *Making a Photograph* (1935). The appeal of these articles, I believe, rested on the impression they gave that technique was at bottom an ethical issue. I doubt that many of Adams' readers understood, or tried very hard to understand, those parts of Adams' sermons that concerned the characteristic curve, or hyperfocal distance, or the function of sodium carbonate in controlling the density of the highlights. But even the youngest and greenest of us could get Adams' basic idea: he was telling us that our hobby was connected to scientific principle and technological rigor, and there was comfort in that. The idea of discipline, mixed with a smattering of chemistry, a little optics, and an original, spirited apostolic voice, persuaded many young photographers that we were engaged in a serious and honorable enterprise. We were grateful for the compliment, even if the seditious suspicion now and then crossed ours minds that our teacher was—just occasionally—attempting to snow us with science. When Adams' analyses left technique and considered aesthetics, suspicion edged toward incredulity. In *Making a Photograph* Adams subjected one of his own photographs to what he called vector analysis, which meant diagramming the existence of patterns of rhythmic proportion, golden sections, etc. As late as 1942 he was still trying to quantify the design of his pictures, even the superb, brooding *Half Dome* (plate 62).[22] This kind of thing was made famous during the period by another Californian, Erle Loran, who explained why Cézanne's

FIGURE 16. Arnold Böcklin. *Island of the Dead,* ca. 1890. The Metropolitan Museum of Art, Reisinger Fund, 1926. (26.90)

paintings worked by superimposing on them various graphic symbols taken (I believe) from highway signs. It can be said in Adams' defense that he defaced only his own work.

To his further credit he did not draw diagrams on *Frozen Lake and Cliffs* (plate 32), one of his most radical and haunting pictures, and perhaps the coldest, most pessimistic landscape picture since Arnold Böcklin's *Island of the Dead*—all ice and knife-sharp stone, rapping out a rhythm like the chattering of a windigo's teeth during the starvation moon.

When we look at Adams' best pictures from the High Sierra, we imagine that they were made by a man alone in the great high silences of romantic solitude, and it comes as a shock to remind ourselves that many of them (including *Frozen Lake and Cliffs*) were made during hours that could be spared from his duties as assistant trail boss of a great movable picnic, composed of up to two hundred nature lovers, some of them virtual tenderfeet, with minimal survival skills, who needed to be led, fed, entertained, and returned to civilization not too much the worse for wear. The clanking of tin cups, the braying of the burros, and the complaints of footsore hikers must have startled romantic solitude into the next mountain range.

Making a Photograph was an impressive success, perhaps primarily because of the genuinely astonishing quality of the reproductions, which established a standard for reproducing photographs in ink that was met during the next twenty years only by some of Adams' subsequent books. The reproductions were photoengravings (relief halftones) printed separately from the text, and tipped onto the page. They were so good that they are still often mistaken for original (chemical) photographic prints.

One might describe the history of photography in the twentieth century as the story of how the old technology of

chemical photography and the new one of photography in ink struggled for hegemony. When Adams was born, halftone reproduction (photography in ink) had only just begun to replace the traditional chemical photograph. During the first third of the century, most of photography's greatest work—e.g., that of Atget, Hine, Sander, Steichen when young, Stieglitz, Strand, Weston—still found its serious public (as small as that public may have been) through the vehicle of the chemical print. (It should be pointed out, however, that photography's new pictorialist subculture was to a considerable degree the invention of Stieglitz's magazine *Camera Work* and its competitors and imitators.) During the middle third of the century, in contrast, the most successful and inventive photographers were for the most part those who believed that the great new opportunity lay in the picture magazines, beginning (in the late twenties) with Edward Steichen and including André Kertész, Margaret Bourke-White, Henri Cartier-Bresson, Bill Brandt, Gene Smith, Irving Penn, etc. Penn stated the position of the new people with clarity and forthrightness: "For the modern photographer the end product of his efforts is the printed page, not the photographic print."[23] By the time Adams had reached middle age, the process was virtually complete; professional photographers made their living by selling not photographic prints but reproduction rights. Except for photographs of potential interest to groups no larger than the nuclear family, photography's business was done in ink. Then a surprising thing happened. By the mid-sixties much of photography's function in the workaday world came to be usurped by the new medium of television, and as photography's commercial function shrank, the chemical ("original") print made a partial comeback, this time not as a vehicle of commerce but as a means of artistic expression.

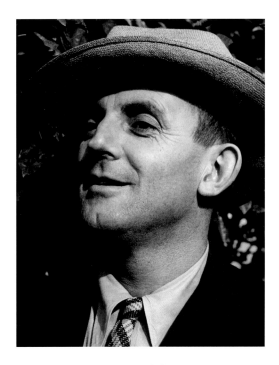

FIGURE 17. Isidore Berger. *Ansel Adams*, ca. 1941. Center for Creative Photography, the University of Arizona.

During much of the century photomechanical reproduction was an issue that divided photographers into two camps. One camp held that photographs in ink could not hope to provide more than a crude approximation of a chemical print, and were therefore of very limited value; the other held that only photographers with nothing of consequence to say would give up the greatly expanded audience that photomechanical reproduction allowed, for the sake of a richer gray scale.

It is typical of Adams' anomalous position in the photographic world of his time that he was a central figure on both sides of this argument. He was without question a major influence in the development of modern halftone reproduction. The best-reproduced photographic books made in America from the mid-thirties to the seventies all seem to have been projects in which Adams was directly and intimately involved. In 1938—three years after *Making a Photograph*—he published *Sierra Nevada: The John Muir Trail*, which equaled the quality of the earlier book and which was in addition a statement of Adams' creative intention rather than a technical treatise. By mid-century he had badgered and cajoled his printers and platemakers into achieving comparable results while printing text on the same page as the photograph.

My Camera in Yosemite Valley (1949) was the first of a series of books that achieved in ink an unprecedented degree of fidelity to the chemical print. Then the economic equation changed, and in the early sixties relief printing disappeared almost overnight. Adams then lent his great energy and personal authority to the new problem of how photographs might be faithfully reproduced in offset lithography. It was a medium that had been regarded since its inception as useful only for the cheapest and most utilitarian of jobs, since the flat aluminum plate could lay down only a thin, anemic skin of ink. But by the sixties offset presses had become so accurate

that they could lay down—again and again—a needlepoint of ink in precisely the same place. This gave birth to what came to be called duotone or tritone printing, depending on how many times the sheet was printed. The plates in this book were printed in a tritone system in which each of three lithographic plates was formed to correspond to a different part of the photograph's gray scale; the image from each is laid down, one on top of another, to simulate as precisely as possible—as precisely as possible today—the character of the chemical print. This book is as good as it is largely because Ansel Adams insisted, all his life, that photographs reproduced in ink could be better, and proved it repeatedly.

One would not expect the photographer who was as central as Adams to the improvement of photomechanical reproduction to also be the photographer who reestablished an interest in the original (chemical) photographic print as a collectable object. But that is the case. In 1948 Adams issued *Portfolio I*: twelve prints, approximately eight by ten inches, mounted and with a letterpress introduction, all enclosed in a simple, tasteful folder. The portfolio was printed in an edition of seventy-five, and sold for one hundred dollars. The project was presumably an effort by Adams to make some meaningful bit of his necessary income by selling his best work, as opposed to the well-made commercial potboilers that he did for Kodak, or the Yosemite Park & Curry Company, or the Paul Masson Wineries; and it was also an effort to distribute his work in its best, more complete form.

At the time, it would have been easy to consider this exercise a half century out of date. In 1948 an "original" print was for professional photographers a means to an end—it was a thing one sent to the printer, which came back (if it came back at all) cracked and dinged and covered with grease pencil markings and areas of airbrushing, to correct the original

picture's inadequacies. In 1948 there was no market for photographic prints. Edward Weston may have sold more prints to collectors than any other photographer; in the mid-thirties, in response to a financial emergency he wrote to twenty-five individuals and institutions, offering to sell to the earliest respondent two hundred and fifty of his best prints—his choice or the buyer's—for one thousand dollars. He had no takers.[24] Twenty years later, in the prosperous fifties, Weston wrote to Beaumont Newhall, soliciting his advice as to whether he dare raise his print price from twenty-five to thirty-five dollars.[25] There were effectively no dealers in photographs, no collectors, and no photographers except Adams naive enough to think one might sell a portfolio of photographs as works of art, as one might sell etchings or lithographs.

Adams' portfolio project might therefore have seemed at the time slightly retrograde to the magazine photographers, but he might have hoped for moral support from the surviving members of the old Stieglitz crowd. He would have been wrong. In a letter of March 1949, Paul Strand told Adams that he was "very disturbed" by the portfolio and accused Adams, in effect, of abandoning the cause of creative photography and the principles of Stieglitz by selling his prints too cheaply. It is not clear from Strand's letter whether he had actually seen the prints; as a matter of principle they could not be good enough at that price. Strand was hardly competent to make this judgment, since his first decent darkroom was still years in the future. He would finally build one in France in the sixties; before that time he had performed his singular miracles in borrowed or improvised darkrooms, and it is not surprising that he should have found it incredible that any photographer could have made seventy-five prints of one negative that were perfect and indistinguishable. Adams' response thanked Strand for his honesty and described in some detail the

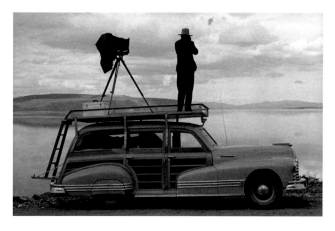

FIGURE 18. Beaumont Newhall. *Ansel Adams at Mono Lake, East Side of the Sierra*, 1947. Center for Creative Photography, the University of Arizona. © The Estate of Beaumont and Nancy Newhall, courtesy of Scheinbaum and Russek, Ltd.

procedures that had enabled him to sell the portfolio at so modest a price. He added that if he could sell a fine print to a large audience for a dollar, he would be delighted. Only near the end of his long letter did his annoyance briefly surface, when he admitted that he could not reconcile Strand's social attitudes (Strand was at least sentimentally a communist) with his views on the appropriate price of art.[26] There followed a hiatus of more than four years in the Adams–Strand correspondence, broken when Adams wrote to congratulate Strand on his book *La France de profil*.

In fact, the quality of the prints in *Portfolio I* is both consistent and very high. In the view of this writer, a number of the prints in the portfolio are among the finest of Adams' career. Still, Strand might have had a point of sorts, even if he did not formulate it clearly. Perhaps the project required too much critical concentration, time, and energy that might otherwise have gone into new work. Perhaps the problem was not that the portfolio cost its buyers too little but that it cost Adams too much.

In 1950 Adams followed *Portfolio I* with *Portfolio II*. Two-thirds of the pictures included in these portfolios were less than two years old when the portfolios were completed, and they include some of Adams' most important work. He was apparently at the top of his game. In 1952 he told Dave McAlpin that *Portfolio III* would be out for Christmas, but it did not appear until eight years later. When it was finally published, it was far more retrospective than either of its predecessors: in fact, more than half of the pictures in *Portfolio III* had been made before the appearance of *Portfolio I*, twelve years earlier.[27] During the decade of the fifties Adams seems to have come to view himself as a historic figure.

It is easy to believe that throughout Adams' life he oscillated between euphoric confidence and racking self-doubt. Or perhaps he was at last freed from that emotional teeter-totter when he finally decided that his creative work was essentially behind him. But in 1950 that decision was still far in the future. In his letters of this period to Beaumont and Nancy Newhall, he repeatedly states his determination to "get back to" his creative work, and also confesses his difficulty in doing so. In these letters he often seems lost as an artist—out of gas, energy, ideas, passion, and more seriously, out of sympathy with his world. Early in 1950 he wrote a remarkable letter to Nancy Newhall about a recurring dream: "Last night I was in a galvanized metal shed in the middle of a dry lake somewhere south of Inyo; there was a hell of a wind blowing and alkali dust was everywhere. I did not like the people I was with in the shed, and I tried time and again to leave—but everytime I opened the door there was such a terrible gust of wind and dust that I was forced to close the door and return to my unsavory companions!"[28] Adams does not make it clear who the unsavory companions were, although in the same letter he speaks at length about his alienation from the broader art community. (Almost a quarter century earlier he had written his sweetheart Virginia Best that "the musical world is the bunk! So much petty doings—so much pose and insincerity and distorted values.") Or the unsavory companions might have been clients, or despoilers of nature, or his conservationist colleagues, or his admirers at the vernissage of an exhibition, or—worst of all—they might have been human society across the board.

But Adams would time and again shrug off the recurring pessimistic strain in his view of the prospects of the world, and his doubts as to his future as an artist, and throw himself back into everyday battles, hopeful that he might in some small measure help save the world from its worst impulses, and also that his muse might, once or twice, tap his shoulder again.

Dreams in any case are the worst of evidence, much less dependable than hearsay. And even if we knew who the unsavory companions in the sheet-metal shed were, or what they symbolized, the knowledge might be of use only to Adams' biographer, or his posthumous analyst, and not tell us anything of use about his work. In our time we have been tempted to think that an artist's work and an artist's biography are fundamentally the same story, written in two languages. It is not difficult to find anecdotal evidence to support this notion. Thoreau, for example, lived (for a year) in a plain, unornamented shack, in which he wrote plain, unornamented prose. Each word that he wrote was joined as naturally and happily to its sentence as a bean to its vine. Further research will perhaps identify those richer passages in his prose that were written after one of his fairly frequent walks into Concord, where he dined at the less ascetic table of the Emersons.

The notion that we can expect some simple correspondence between the character of the life and that of the work seems to me sentimental and misleading. On the other hand, it might be reasonable to infer a correspondence between the life and the absence, or the cessation, of work. The fifties was a difficult time for Adams. In 1952 he confessed to the Newhalls that he was becoming less and less interested in making photographs, and more and more interested in how they could be used. The thought even crossed his mind that—as he had earlier had a life in music, and moved on—now perhaps he had had his life in photography, and should again move on.[29]

The function of this essay is to consider Adams as an artist, not as an educator or a proselytizer for the art of photography or an environmentalist; but it is true that he had only one life to live, and it must be true that his extra-artistic activities were connected to and affected his work as an artist.

FIGURE 19. Ansel Adams at the piano with photography gear, n.d. (photographer unknown). Center for Creative Photography, the University of Arizona.

Without ever consciously deciding to do so, Adams spent much of his photographic life as a teacher, in a variety of venues: in workshops and in traditional art schools; by writing criticism; through his extraordinary *Basic Photo* series of technical manuals; through didactic theme exhibitions and books (most notably *This Is the American Earth*, with Nancy Newhall); and by founding new institutions, and persuading existing museums and schools to consider photography an essential part of their critical and intellectual responsibility. If we remembered not a single Adams photograph, his work as a teacher, in this encompassing sense, would stand as a heroic contribution to photography's future.

In regard to the problem of how one might train a photographer, Adams' pedagogical philosophy was based, I suspect, on that of his first piano teacher, Miss Marie Butler: "She insisted on week after week of grueling exercises and repetitious scales that I felt to be purposeless. Then one autumn day I suddenly realized what was happening. The perfection was beginning to mean something to me! Miss Butler seemed to recognize my awareness and said, 'It's time for a little phrasing.'" [30]

It seems to me improbable that a pedagogical method designed to produce concert pianists would produce good photographers, but the relationship of Adams' *own* work to his musical training is a subtler issue. I believe that Adams' understanding of photographic craft was quite directly a reflection of his understanding of musical craft. When he talked about "chords of tone" in the photographic print, and about the idea that the chords of tone in the dark end of the photographic gray scale should be in tune with the related chords of tone of the high end of the gray scale, I believe that he was describing a personal ideal of photographic craft that may have derived from the harmonic vocabulary that is the basis of Western music.

Adams' interest in the issue of how photographs might be better seen, used, and understood can be traced back to the early years of his professional career: from the early thirties he lobbied vigorously with the San Francisco museums to include photography in their programs. The so-called Group f/64— to the degree that it had any significance—was perhaps noteworthy chiefly because it had been awarded a group exhibition at the M. H. de Young Memorial Museum in 1932.

Adams never stopped working for more serious and more effective institutional attention for the intelligent preservation, study, exhibition, and publication of the photographic enterprise. By 1940, when he organized the exhibition *A Pageant of Photography* for the Golden Gate Exposition, he had known David McAlpin for three years. McAlpin, an investment banker and new trustee of The Museum of Modern Art, had bought eight prints from Adams' 1936 show at An American Place, and had the next year anonymously funded Beaumont Newhall's groundbreaking historical exhibition *Photography: 1839–1937*. In 1937 Adams, McAlpin, Georgia O'Keeffe, and Godfrey Rockefeller met for a sightseeing trip to New Mexico and Arizona, and Adams and McAlpin became friends. In 1940 Beaumont Newhall, still by title the Museum's librarian, traveled west, perhaps in part to discuss with Adams his ambitions for a curatorial department of photography. When their mutual enthusiasm reached critical mass, it was Adams, not Newhall, who said, "It's time to call Dave." [31] A little later, McAlpin told Adams that he would accept the position of trustee chairman of the projected department only if Adams agreed to come aboard as "advisor, organizer, and policy director." [32] Adams accepted with alacrity, and during the following years spent considerable time and energy helping devise and execute the department's program.

In the process he became an even closer friend, ally, and confidant of Beaumont Newhall, curator of the department, and of Newhall's wife, Nancy, who served as acting curator while her husband was serving, during much of World War II, as a photo-reconnaissance officer in the Army Air Force. By the time Newhall returned to the Museum late in 1945, considerable support had been attracted to the idea that the department would prosper—financially and otherwise—if directed by the photographer Edward Steichen, who had retired from commercial practice in the late thirties and who (while a lieutenant commander in the navy) had directed two very popular Museum exhibitions on wartime themes. When Steichen accepted the job of director of the department, Newhall declined to continue as curator, and left the Museum.

For Newhall it was doubtless a traumatic experience, but he went on to become the first curator and soon the director of George Eastman House, the museum of photography just established in Rochester, New York, where he continued his long and distinguished career. The shock of leaving the Museum was surely greater and longer lasting for Nancy Newhall, who had organized many photography exhibitions during the wartime years, and perhaps also to Adams, who had contributed much to the original conception of the department and whose opinion was not solicited about the change. It is not clear whether his letter of protest over Steichen's appointment,[33] and his resignation from the Advisory Committee, was answered.

It seems clear that Adams felt rejected by the Museum; in addition, he had long disliked Steichen, a position based partly on principle and largely on chemical antipathy. These two perspectives seemed now to turn him against most photography that the Museum appeared to favor—and finally against most photography done outside of California, unless it had been shown by Stieglitz. Adams and Nancy Newhall, who had not found work to fulfill her in Rochester, seem at this point to have formed a kind of alliance, dedicated to the advancement of Adams' work and—more broadly and more problematically—to a narrowing view of photography's potential.

The collaboration between Adams and Nancy Newhall resulted in a long list of books, magazine pieces, and exhibitions, including the largest of Adams' exhibitions, *The Eloquent Light*, which opened in 1963 at San Francisco's de Young Museum with more than five hundred photographs. As is not uncommon—especially with exhibitions dealing with the work of living artists—the show was designed not only to define Adams' artistic achievement but (consciously or otherwise) to serve at least two additional agendas.

First, the show was (naturally and properly) designed to serve the perceived needs of Adams' career at the moment. At the age of sixty-one he was still struggling to support himself as a commercial photographer while fitting his personal work into those scraps of time left to him after he had satisfied the demands of a brutal schedule. Surely he would have hoped that the right exhibition might bring him the kind of enlightened support that would allow him to put his commercial work behind him. If the exhibition was to have broad popular appeal, perhaps it should be slanted toward the dramatic and expressionistic, as opposed to the lyric and exploratory. This was in any case the direction that Adams' later work had taken, and it was surely in keeping with the very romantic tastes of Adams' collaborator.

In addition, I think it can be assumed that both Adams and Nancy Newhall saw the exhibition as an opportunity to combat what seemed to them a tragic retreat from the conception of creative photography that had been represented by Alfred Stieglitz. That high ideal had in their eyes been

sullied by commercialism and opportunism in high places and by the abandonment of craft (as Adams understood the term) and the moral virtues that it represented.

The act of selecting (with Newhall) the 1963 exhibition was perhaps the last time that Adams ever looked and thought hard about the meaning of his work and the definition of his œuvre. At that point his view of himself as an artist was fixed and his future representations of his work came almost wholly from the checklist of that exhibition. As a social and political being, he continued to grow in subsequent years, but as an artist and as a critic of photography, he became reduced to replaying a severely abridged version of his earlier self.

Perhaps the most impressive achievement of the collaboration between Adams and Nancy Newhall was the exhibition *This Is the American Earth*, and especially the highly influential book of the same name, which Justice William O. Douglas called "one of the great statements in the history of conservation."[34] The book is primarily an album of splendid landscape photographs accompanied by a long prose poem by Newhall, which recounts the predominately unhappy history of man's treatment of his world and looks forward to a new moral order based on man's understanding of his dependence on the environment as an organic whole. More than half of the book's photographs are by Adams, but work by twenty other contemporary photographers is included, as well as a handful of historical pictures. Of the twenty, the large majority lived and worked west of the Missouri. Those who worked elsewhere were represented by photographs that illustrated ecological failure—Arthur Rothstein by an eroded, clearcut field, Werner Bischoff by starvation in India, Cartier-Bresson by a photograph of a boy who appears to be hiding in a mazelike urban street, with no blade of grass in sight. Intentionally or otherwise, the book projects a Calvinist insularity. It appears to see most of the world as beyond salvation, and the American West as the last chance for New Jerusalem.

When Adams hinted to his friend Edward Weston of his concerns about his life as an artist, Weston encouraged him to simplify: simplify his life, cut his costs, learn to say no to everything that came between him and his high artistic ambition. But Adams could not do it. In fact, his enthusiasm for almost any new assignment seemed to wax rather than wane as he advanced into middle age. He did need the money (unless he chose to abandon his middle-class responsibilities, and live in one room, on fruit and oatmeal, like Weston), but that is perhaps not the whole story. Perhaps an additional function served by his commercial assignments, and his Sierra Club activity, and his educational and curatorial ventures, and his mountainous correspondence, was that of distracting his attention from the dry periods in his creative work. He confessed these concerns most frankly to his best friends, Nancy and Beaumont Newhall. In July 1951 he wrote that "when this is over [meaning that when his beloved father had completed the slow process of dying] I shall get back to creative work. I begin to doubt myself, because I have felt it so often and nothing happened!"[35] Less than a month later his father died, and he wrote to say that "at the moment, I feel that when I get my existing negatives really printed I will have consummated what I have to say in photography."[36]

It is surely true that doubt is the constant companion of most artists, who wonder whether they will ever again do anything as good as they did earlier—whether that was thirty years ago or last week—and it is also true that many artists are given to posturing, and to claiming, even when they are scarcely old enough to vote, that their creative powers have

abandoned them. Nevertheless, Adams might have had better reasons than most for fearing that at the age of forty-eight his best years as an artist were behind him. And as things worked out, his fears were largely justified.

Adams' career reminded the photographer Frank Gohlke[37] of that of Wordsworth, who completed almost all of his great poems by the time he was thirty-five, and then lived to eighty, a great and honored man without a clear sense of what use to make of his remaining years. Adams was luckier than that. He had for at least twenty years worked at or near the top of his form, and after that he had a rich career as a teacher, and as a conservationist, and as an editor revising and arranging for publication his own earlier work. We should assume that he had recognized that he had done the work that his own genius had asked of him—and had permitted him.

Adams' options were limited, since he was by nature a lyric artist, dependent on the quality of his immediate experience and not available to the more intellectually ambitious forms dependent on an epic sense of history, or cultural narrative. Without doubt he would have found such an appraisal unfair, and during his lifetime he made great efforts to prove that it was false, even before it had been made. His effort to prove that he was not merely a great poet of the wild landscape made him a poor editor of his own work. Even as early as *Making a Photograph* he had demonstrated what became the habit of illustrating his technical books with a curious mixture of his best pictures and other deeply tedious ones. It is of course true that the intention of the book was primarily technical, but one would expect an artist of Adams' ambition to use the opportunity of the book as a showcase for his best work. Good pictures illustrate technical principles as well as boring ones. The answer may be that he was anxious to demonstrate that he was not just an artist but a competent professional who could

FIGURE 20. William Heick. Dorothea Lange and Ansel Adams at the California School of Fine Arts, now the San Francisco Art Institute, ca. 1950. Center for Creative Photography, the University of Arizona.

handle a wide range of fundamentally pedestrian commercial assignments. If so, it seems an odd and self-defeating strategy.

Even in the selection of pictures for his late *Portfolios*, when he was perhaps more popular and more widely known than any other living photographer, and when he no longer needed to interest himself in commercial assignments, one senses that he was still trying to prove that he could do what the next man (or woman) could do; that he could do Walker Evans if he chose, or Aaron Siskind, or Dorothea Lange.

After Weston and Strand, Adams probably admired Lange more than any of his other approximate contemporaries, and she, in her grudging, qualifying way, admired him. But it seems clear that they did not understand each other. Lange harshly criticized Adams' book *Born Free and Equal*, on life in the World War II "Japanese" relocation camp at Manzanar. She felt that Adams' pictures seemed to gloss over the injustice that had been done. This criticism seems to me to miss the point. Adams' idea was to show that the Issei and Nisei, in spite of the injustices that they had suffered, had maintained their cohesion, their dignity, and their will. This seems to me a wholly admirable ambition—perhaps even preferable to that of those who were willing to photograph the people of the camps merely as victims. The problem was not Adams' moral stance but his pictures, which—like his portraits even of his close friends—were generally wooden and opaque. Adams said more than once that it was his aim in making a portrait to photograph the head as though it were a piece of sculpture. Regrettably, he too often succeeded in this bizarre ambition.

Adams' dissatisfaction with the nature of his own talent was perhaps the thing that created such a remarkable gap between his best and his least work. It is difficult to think of another photographer of comparable stature whose best and worst were so distant in quality. One might nominate Adams' bête noire

Edward Steichen, whose advertising work, especially, was presumably often embarrassing even to his most dedicated fans. But even the least of Steichen's work had a professional panache and confidence about it, whereas Adams' commercial work—excepting the landscape assignments done for magazines such as *Holiday* and *Arizona Highways*—seldom transcended technical competence. His handling of human models was stiff and unpersuasive, even by the low standards of most advertising photography; his industrial illustration seldom gives any sense of work being done; in his reportage nothing of interest happens.

It is unnecessary to pause further over Adams' commercial work, except to note that it kept him alive and precariously solvent until he was seventy, at which late date he began to make a living income from what had been for almost half a century his true work.

At least quantitatively, Adams was one of the great correspondents of the time, typing away late into the night and again early in the morning, spinning out millions of words—multipaged, single-spaced harangues to best friends, potential friends, allies, and antagonists, and postcards, covered to the edges with whatever type Adams favored at the moment, often sans serif and in the early years elite, until his eyesight began to fade a little. His correspondence was a testament to his enormous energy, and a demonstration of his wide range of interests. The letters are often full of charm and voyeuristic fascination, especially when he is typing late at night, when bourbon has relaxed the inherited habit of Yankee propriety. The correspondence is also full of rich material for his biographer, or a historian of the conservation movement, or of American photography, but it finally tells us less than we want to know about Adams as a man or as an artist. A few

letters to Edward Weston come closest, perhaps, to plain speech about his values as an artist, and a few to Beaumont (or more often Nancy) Newhall reveal his deep reservations about the culture he lived in, but there remains at the center a nut-hard secret.

A small part of Adams' correspondence is devoted to trying to persuade his rich friends that his work needed and deserved support. He was, alas, not good at writing the kind of letter that might have gotten results. In 1952 Adams wrote a seven-page, single-spaced, typewritten letter to his friends George and Betty Marshall which I *believe* is an appeal for financial help.[38] I am, however, not sure; and it is possible that the Marshalls were not sure, either. Adams did get a little support from his friend David McAlpin (who got in exchange—unsolicited—a cornucopia of Adams' best prints), and more from his friend and neighbor Dick McGraw and from his friend Edwin Land, who paid Adams to experiment with his Polaroid films, and perhaps from others. But such help never gave Adams what he needed, and it is not clear that Adams ever told any of his friends or potential supporters, in one hundred words or less, precisely what it was that he did need. Perhaps he was not sure.

Adams' greatest work was done in the thirties and forties, and by the end of this time (to repeat) he was famous, even if financially insecure. After Stieglitz and Steichen (one of whom, many people knew, was the husband of Georgia O'Keeffe) and possibly Margaret Bourke-White, he was perhaps the best-known American photographer. Nevertheless, he and his work were not universally admired. Adams was in fact never quite in step with the drummer of the political moment. During the thirties he did not photograph the dust bowl, or the Okie migration, like Dorothea Lange, nor did he measure the pulse

FIGURE 21. Brian Berry. Ansel Adams with a photography class at Yale, 1970. Seated by Adams is Bill Turnage, now a trustee of the Ansel Adams Trust. Center for Creative Photography, the University of Arizona.

FIGURE 22. Morris Engel. *Ansel Adams at The Museum of Modern Art*, New York, 1979. Center for Creative Photography, the University of Arizona. © Morris Engel.

of American culture, like Walker Evans. In the forties he did not photograph World War II and lesser conflagrations, like Robert Capa, or the death camps, like Margaret Bourke-White. He was instead somewhere in the High Country, making photographs that would neither end the Great Depression nor help win the War. Some felt that his work was not quite relevant; their feeling was summed up most memorably a little later in a purported remark of Henri Cartier-Bresson to Nancy Newhall: "Now in this moment, in this crisis, with the world maybe going to pieces—to photograph a *landscape!*"[39] Newhall did not say whether Cartier-Bresson specified what a photographer should photograph while the world might be going to pieces, but it seems clear that his remark was not frivolous and that he had given the matter serious thought in regard to his own work. It would seem that about this time Cartier-Bresson decided that it was no longer good enough to photograph a man jumping over a puddle, or a boy bouncing a ball against a wall, or other such innocuous, quotidian scenes and that a photographer should instead make photographs that were more likely to be of interest to the magazines. Such photographs were made in places where large issues were in the balance—generally places on continents other than one's own. The magazines may have hoped that the photographer's innocence concerning the meaning of his subjects might add a certain piquancy to his or her observation.

During his best years Adams was photographing (from a political point of view) the wrong subjects. Years later, after Aldo Leopold and Rachel Carson had helped change the climate of values, Adams was credited, retroactively, with being socially relevant after all, but the prize was awarded on the basis of a misunderstanding. Adams did not photograph the landscape as a matter of social service, but as a form of private worship. It was his own soul that he was trying to save.

The young Adams wrote, "I saw more clearly than I have ever seen before or since the minute detail of the grasses, the clusters of sand shifting in the wind, the small flotsam of the forest, the motion of the high clouds streaming above the peaks." He was confessing to a private knowledge that is almost surely incommunicable but that he was nevertheless obliged to attempt to photograph. But there is—alas!—no way to test the public, objective picture against the private, subjective experience: no trustworthy way to measure how well the art matches the emotion. One might even suspect that, to the degree that the art succeeds, it has so distanced itself from the emotion that the latter is remembered only like an old love. Wordsworth said that poetry was emotion recollected in tranquillity, meaning that good poems are written in cold blood, as good generals fight wars. And yet behind the calculation, the knowledge, the expert cabinetmaking, there must stand the vital memory of deep experience, against which we try to measure the adequacy of what is at best only a picture, or a poem.

Ansel Adams' great work was done under the stimulus of a profound and mystical experience of the natural world. When he attempted to work without the support of that knowledge, or when its memory had become blunted or blurred, he was capable of empty self-imitation, but for the most part he declined to work without motive. In 1958 he made his superb *Aspens, Northern New Mexico* (plates 104 and 105) and in 1968 one of the best of his splendid pictures of El Capitan (plate 113), but in general the fifties and the sixties were dry decades, and after that Adams' energies were devoted to his duties as a conservation leader and to the obligations of fame, and to the reinterpretation of work done years before.

Toward the end of his career this reinterpretation seemed at times to amount almost to parody. The lyrical precision and perfect balance of his earlier work he reworked in his old age, too often replacing the elegance with melodrama, and the reverence with something approaching bombast. His consistent response to implicit queries about his radical recasting of his earlier work seems fundamentally an evasion: he said, "The negative is the score, and the print is the performance." Granted, but as a musician Adams had surely heard too many performances that had trespassed beyond the most elastic boundaries of the score's meaning and floundered into caricature. The change imposed on *Mount McKinley and Wonder Lake* thirty years later is not easy to understand (plates 109 and 110). Why this radiant peak, a reflection of our highest and purest aspirations, should have been transformed into a dirty snowdrift is a mystery to this viewer.

And yet it was surely Adams' right to make the change, and we should not be too swift, or too confident, in judging him wrong. It has been suggested that the change may have been caused by Adams' faltering vision, but the explanation seems not wholly persuasive.[40] And in fact, perhaps there is a kind of logic in the radical late prints: perhaps they describe the completion of a change of view that had been taking place for many years. Those who are committed to the idea of art as self-expression might value these late prints as the last testament of an artist whose view of the world and the future had darkened.

Adams was—by strength of will, if not by nature—an optimist. As an optimist he saw the forces of environmental responsibility as ascendant, and the minds and hearts of the people moving steadily toward the understanding that something similar to reverence for our planet was the essential precondition to ethical life on it. He could point to many victories in support of this optimistic view: new parks, new laws, burgeoning memberships for environmental organizations, etc., and these victories were undeniably real.

FIGURE 23. Martha Hartnett. *Ansel Adams*, n.d. Center for Creative Photography, the University of Arizona.

But in between the parks and the national monuments and the wilderness areas—in the farming country, and the grazing country and the logging country and the mining country, even on public lands, and on the ocean banks, and along the lengthening strip developments, and in the new suburbs that no longer related to an urban center—the picture provided much less ground for cheer.

As a conservationist, a democrat, and a deeply moral man, Adams was committed to the social duty of doing the best he could, of making the best possible bargain, of slowing the advance of barbaric greed until there came a great change of heart, or until some great geologic objection might resolve the question in its own unanswerable way. But in his darkroom he did not need to be the reasonable, responsible, kindly representative of a reasonable position; perhaps there he could give free rein to his intuition of the future.

William James held that order and disorder were human inventions. I think that most artists would disagree. The elder Renoir said, "At the start I see my subject in a sort of haze. I know perfectly well that what I shall see in it later is there all the time, but it only becomes apparent after a while."[41] Adams would also disagree, perhaps citing harmonic overtones to support his view. But if finally brought into James' light, he might then insist that, once invented, the new structures of order are factual and objective, and possibly even permanent, within the measure of man's tenure.

The interests of an artist and of his audience are in the end quite different. As Adams' audience we are grateful to him for enlarging our emotional knowledge of the natural world, the knowledge of its constant mutability—that it is (one might say) alive. If we avert our eyes for a moment, we will

return them to a different world, a constant source of wonder and deep surprise, which we love not only as an aesthetic delight but as a deep moral cryptogram to which we have no key.

An artist is also a member of art's audience, and as such shares our interests; but finally he is interested in something else. He is interested in demonstrating to himself, by the authority of his work, that his world is not an illusion, not an invention of the imagination, but rather a real world, of which he is therefore a real part. So if we ask the question, what did Ansel Adams do for us? one useful answer would be: nothing; he did it all for himself.

NOTES

1. Edward Weston, "Random Notes on Photography" (1922), reprinted in Beaumont Newhall, ed., *Photography: Essays & Images* (New York: The Museum of Modern Art, 1980), pp. 223–27.
2. William James, *The Varieties of Religious Experience* (New York: Modern Library, 1994), pp. 478n, 168.
3. Ansel Adams with Mary Street Alinder, *Ansel Adams: An Autobiography* (Boston: Little, Brown and Co., 1985), p. 17.
4. Nancy Newhall, *Ansel Adams: An Eloquent Light* (San Francisco: The Sierra Club, 1963), p. 129. Anne Adams Helms, Adams' daughter, has written to suggest that my account exaggerates the possible tensions in the house of Adams' parents, and to say that on her own visits to their home she saw her grandfather behave in a gentle and courteous way to his wife and his sister-in-law (AAH to JS, 8 Jan. 2001). I certainly do not mean to impugn the manners of Adams' father, which were apparently beyond reproach. In any case, I am considering not the relationship between Adams' parents but the quality of Adams' own early life at home. His autobiographical writings, and most especially his letters, are full of praise of and appreciation for his father, but not even an affectionate nod to his mother, as far as I have noticed.
5. John Szarkowski, *Mr. Bristol's Barn: With Excerpts from Mr. Blinn's Diary* (New York: Harry N. Abrams, 1997), p. 3.
6. Anne Hammond, *Divine Performance: The Landscape Photographs of Ansel Adams*. In preparation. Typescript p. 3.
7. Mary Street Alinder and Andrea Gray Stillman, eds., *Ansel Adams: Letters and Images* (Boston: Little Brown and Co., 1988), p. 1.
8. Charles Adams to "My dear Mother and Cassie," 17 May 1914, Archives of the Center for Creative Photography (hereinafter, CCP), University of Arizona. Henry Cowell (1897–1965) did in fact become an important American composer and theorist who attempted to find a common foundation for Western and Eastern musical traditions.
9. Mark A. Greene of the Henry Ford Museum says that the price of 1925 Fords ranged from $260 (for the Runabout) to $660 (for the Fordor).
10. *Letters*, p. 25.
11. *Autobiography*, p. 109.
12. Beaumont Newhall, *Focus: Memoirs of a Life in Photography* (Boston: Bulfinch Press, 1993), p. 235.
13. *Letters*, p. 29.
14. Ibid., p. 30.
15. *Autobiography*, p. 82.
16. The record is not yet complete. The collections of the Bancroft Library contain in addition albums of Adams' prints from the High Sierra from 1920 and 1945, but it is not clear that these relate to Adams' presence on official Sierra Club Outings. It should also not be assumed that the Bancroft collections are complete.
17. *Autobiography*, p. 76.
18. *Letters*, p. 56.
19. *Autobiography*, p. 109.
20. *The Eloquent Light*, pp. 36–37.
21. William James, op. cit., pp. 278, 419.
22. Ansel Adams, "A Geometrical Approach to Composition," in *The Complete Photographer* 30:5, July 1942, p. 1923.
23. A transcript of the symposium "What Is Modern Photography?" held on October 20, 1950, is in the archives of the Department of Photography of The Museum of Modern Art.
24. A Xerox copy of the photographically reproduced letter is in the archives of the Department of Photography of The Museum of Modern Art. Cole Weston estimated the date of the letter as ca. 1935–36.
25. Edward Weston to Beaumont Newhall, 12 June 1954, CCP.
26. *Letters*, pp. 206–07.
27. William Turnage believes that Adams suffered a nervous breakdown of sorts after his father's death in the summer of 1951 and that the condition persisted for eighteen months or two years. If so, it would not seem to adequately explain the further seven-year delay in completing *Portfolio III*.
28. *Letters*, p. 215.
29. AA to Beaumont and Nancy Newhall, 20 Sept. 1952, CCP.
30. *Autobiography*, p. 23.
31. Newhall, *Focus*, p. 61.
32. *Letters*, p. 119.
33. AA to Stephen Clark, *Letters*, pp. 170 ff.
34. Douglas' comment is printed as a testimonial on the dust jacket of the book.
35. *Letters*, p. 218.
36. AA to Beaumont and Nancy Newhall, 21 Aug. 1951, CCP.
37. In conversation with the author, September 2000.
38. AA to "Dear George and Betty," 22 June 1952, CCP.
39. Nancy Newhall, "Controversy and the Creative Concepts," *Aperture*, no. 2, 1953. Reprinted in N. Newhall, *From Adams to Stieglitz* (New York: Aperture, 1989), p. 4.
40. Andrea Stillman was told by Pirkle Jones that when he worked as Adams' assistant in the early and mid-fifties, Adams was already rejecting (and destroying) his earlier prints because they "were weak and lacked strength." (Memorandum from Andrea Stillman to Leslie Calmes, CCP, 8 Jan. 1998.) There is no indication that Adams' eyes were failing in this period. William Turnage and Andrea Stillman, both very close colleagues of Adams during the period in question, give greater weight than I to the influence of Adams' declining vision on his printing style. Stillman writes (AGS to JS, 4 Jan. 2001) that although the shift in Adams' printing style "for most of his life was very gradual… the dramatic shift from about 1978–79 was altogether different. It was no longer just an aesthetic change for more drama but a need to compensate for his inability to actually 'see' black."
41. Jean Renoir, *Renoir, My Father* (Boston: Little, Brown and Co., 1962), p. 202.

I FALL IN UPPER TENAYA CANYON,
YOSEMITE NATIONAL PARK, CALIFORNIA
CA. 1920

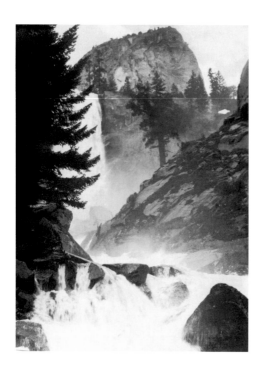

2 VERNAL FALL THROUGH TREE,
YOSEMITE VALLEY, CALIFORNIA
1920

3 MERCED PEAK FROM RED PEAK,
YOSEMITE
CA. 1920

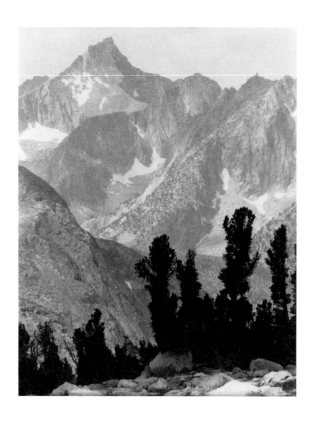

4 MOUNT CLARENCE KING,
 SIERRA NEVADA, CALIFORNIA
 CA. 1923 (1927)

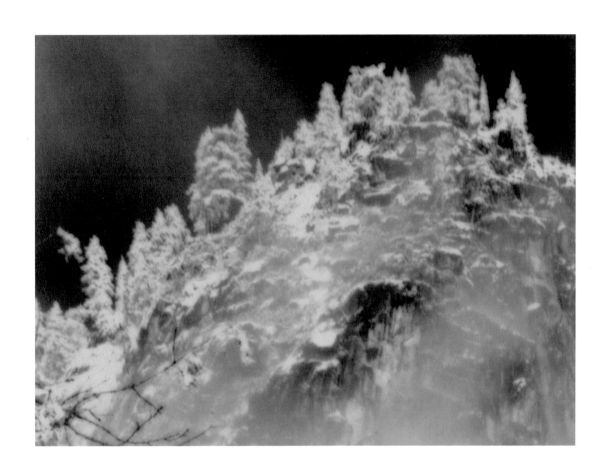

5 ROCK FACE AND TREES IN WINTER
 1928

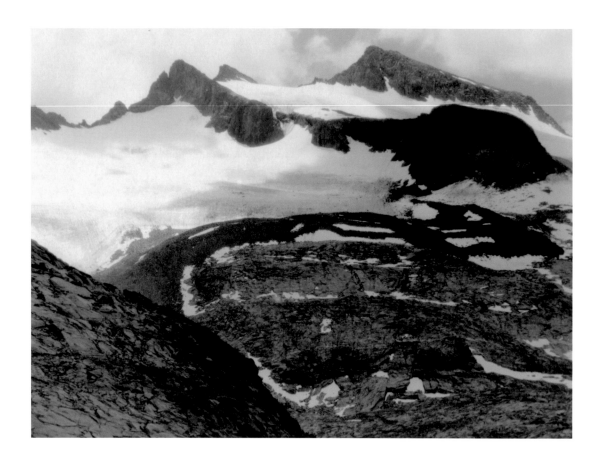

6 MOUNT LYELL AND MOUNT MACLURE,
 HEADWATERS OF TUOLUMNE RIVER, YOSEMITE
 1929

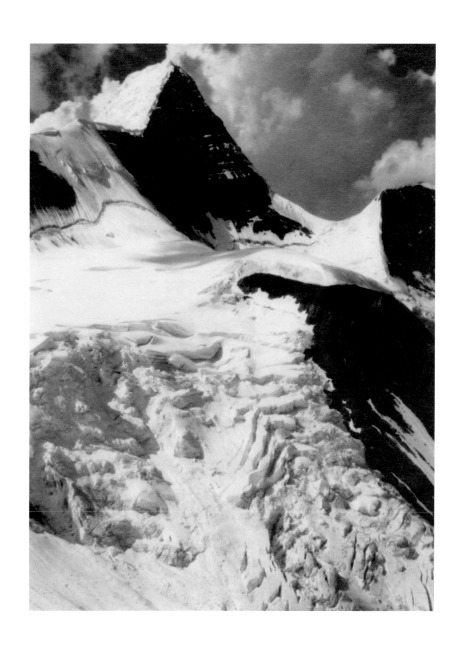

7 MOUNT ROBSON,
JASPER NATIONAL PARK, CANADA
1928

8 EAGLE DANCE, SAN ILDEFONSO PUEBLO,
NEW MEXICO
1928–29

9 GRASS AND WATER, TUOLUMNE MEADOWS,
YOSEMITE NATIONAL PARK
CA. 1935

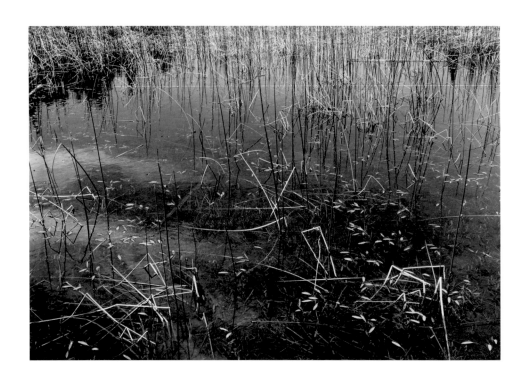

10 POOL, TUOLUMNE MEADOWS
CA. 1935

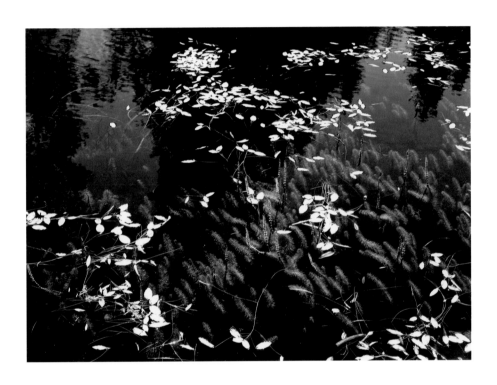

11 LEAVES ON POOL
CA. 1935

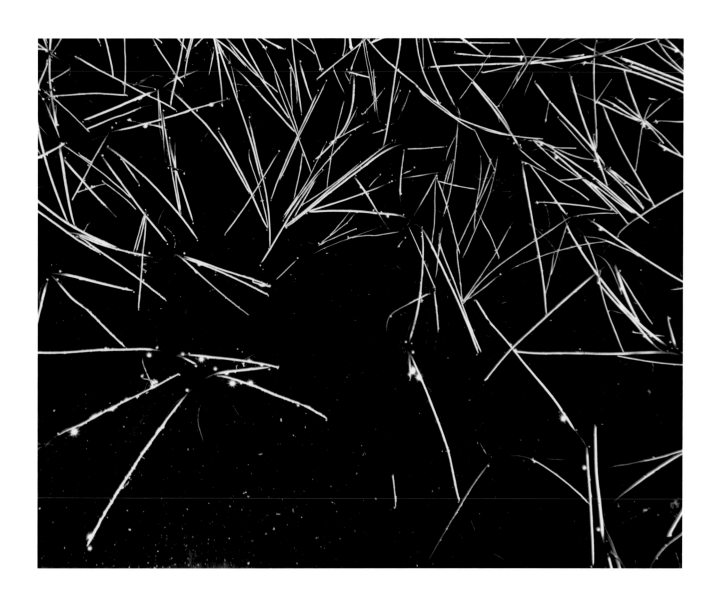

12 GRASS AND POOL
CA. 1935

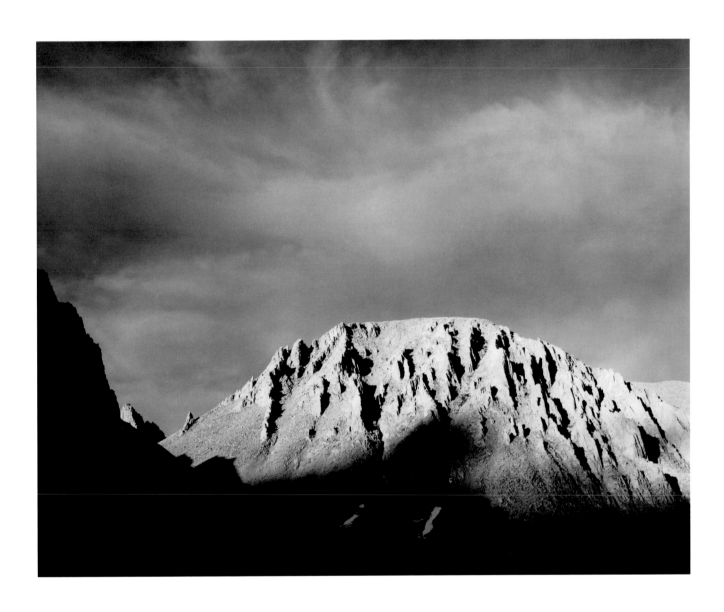

13 MOUNT WHITNEY FROM THE WEST,
SIERRA NEVADA
CA. 1932 (1936)

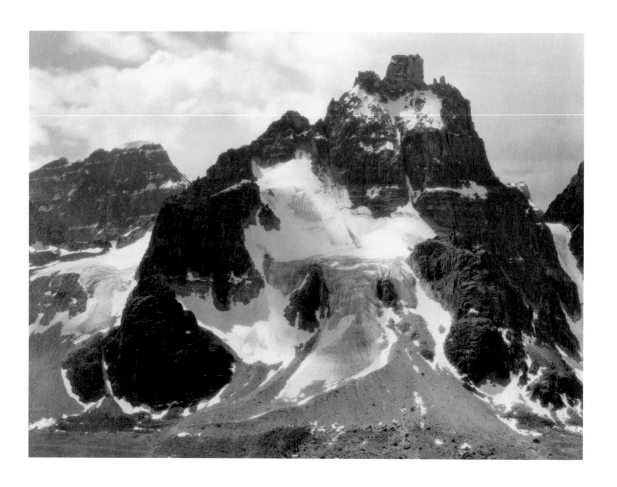

14 CAJIMONT-BAJRION,
CANADIAN ROCKIES
1928

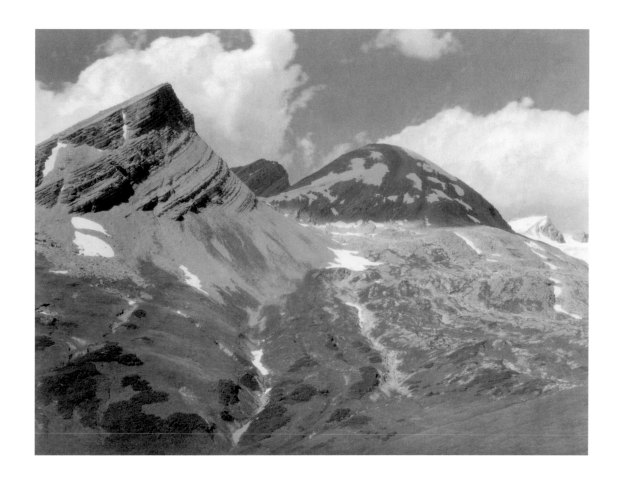

15 NEAR MOOSE PASS,
 CANADIAN ROCKIES
 1928

16　SIMMONS PEAK,
IN THE MACLURE FORK CANYON, YOSEMITE
CA. 1924

17 THE BACK OF HALF DOME,
 YOSEMITE NATIONAL PARK, CALIFORNIA
 CA. 1920

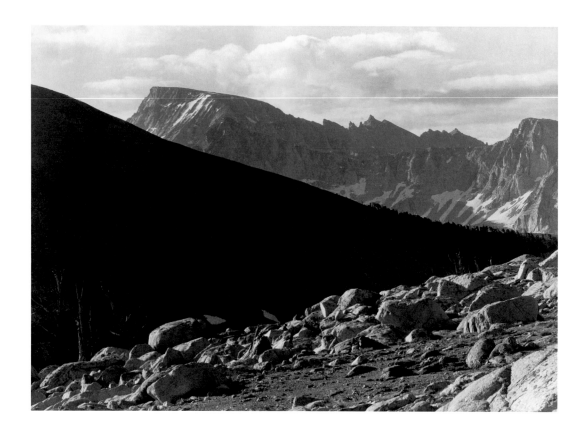

18 MOUNT WHITNEY
N.D.

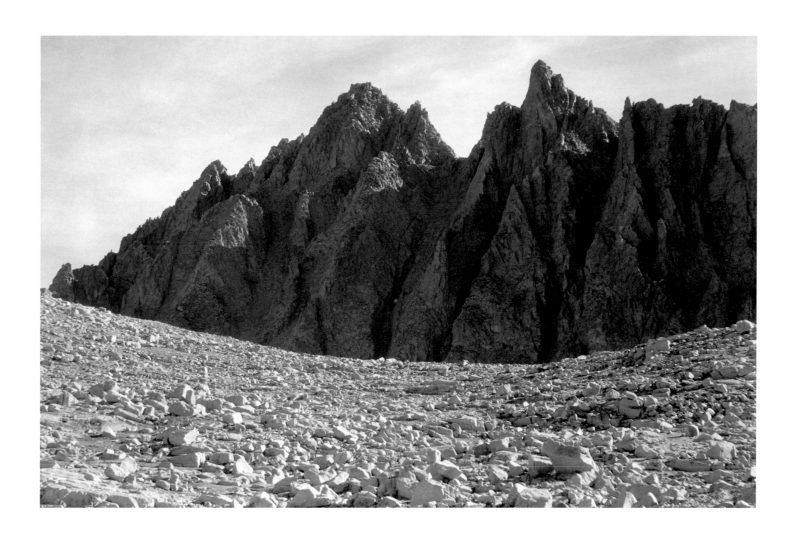

19 BISHOPS PASS,
 KINGS RIVER CANYON
 1936

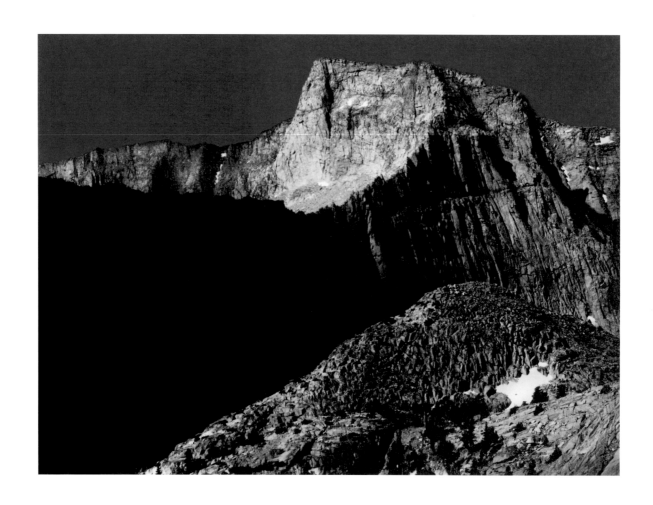

20 GLACIAL CIRQUE, MILESTONE RIDGE,
 SEQUOIA NATIONAL PARK, CALIFORNIA
 CA. 1927

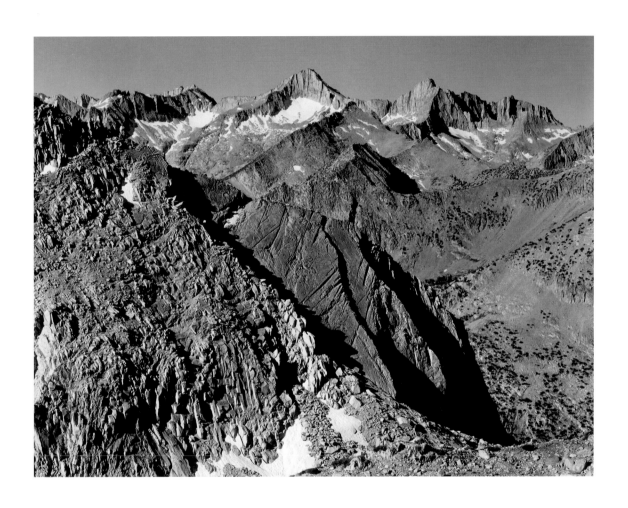

21 MOUNT BREWER GROUP FROM GLEN PASS,
SIERRA NEVADA
1935

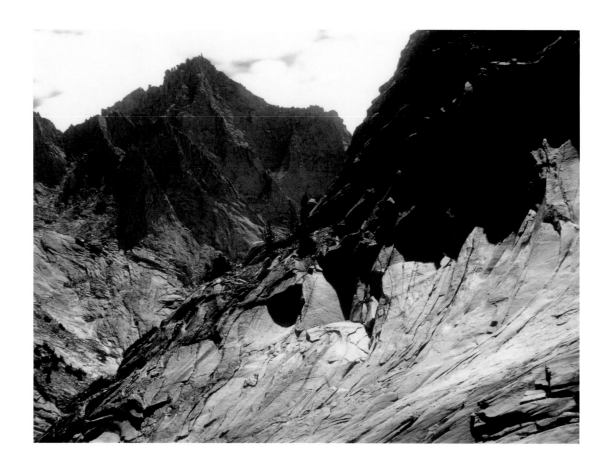

22 PEAK ON GLACIER RIDGE
CA. 1925

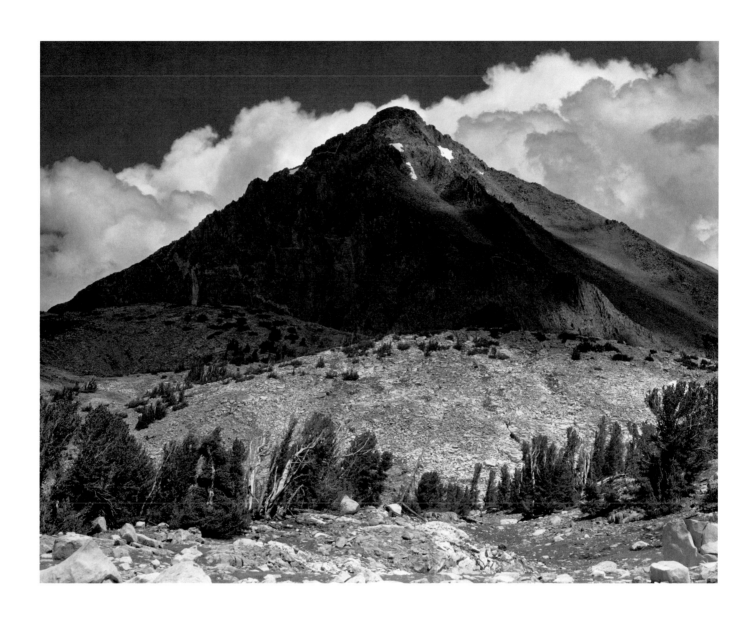

23 PINCHOT PASS, MOUNT WYNNE,
KINGS RIVER CANYON
1936 (1935)

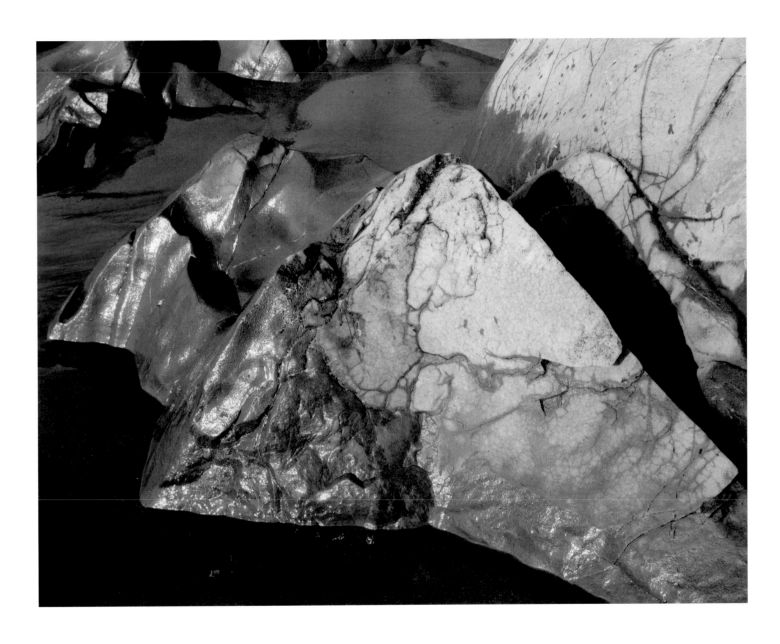

24 ROCKS, BAKER BEACH,
 SAN FRANCISCO, CALIFORNIA
 CA. 1931

25 HELMET ROCK, LANDS END,
SAN FRANCISCO
1918

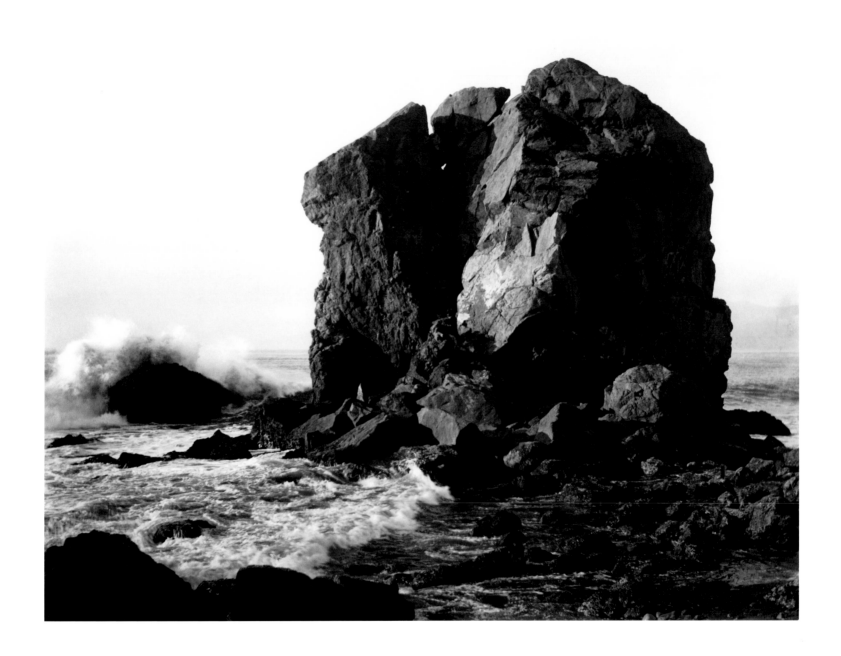

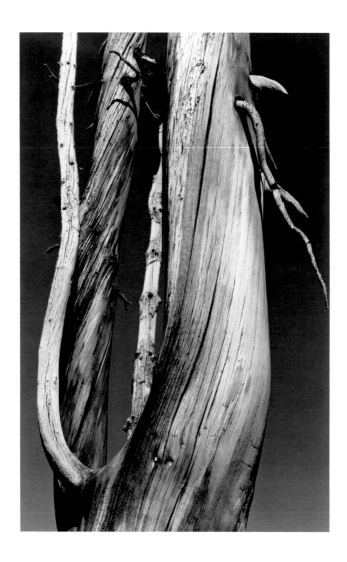

26 DEAD TREE, DOG LAKE,
YOSEMITE NATIONAL PARK
CA. 1936 (1933)

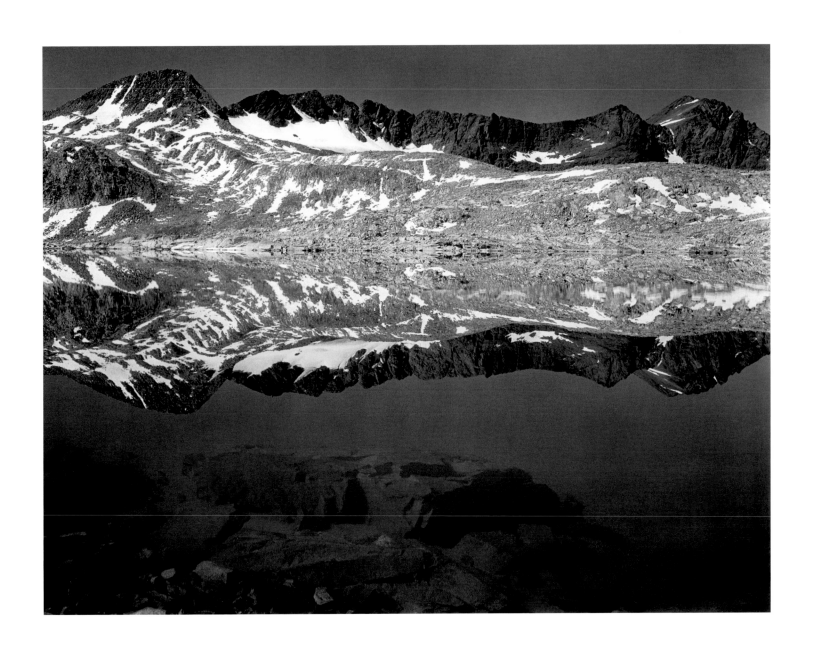

27 WANDA LAKE, NEAR MUIR PASS,
KINGS CANYON NATIONAL PARK
CA. 1934

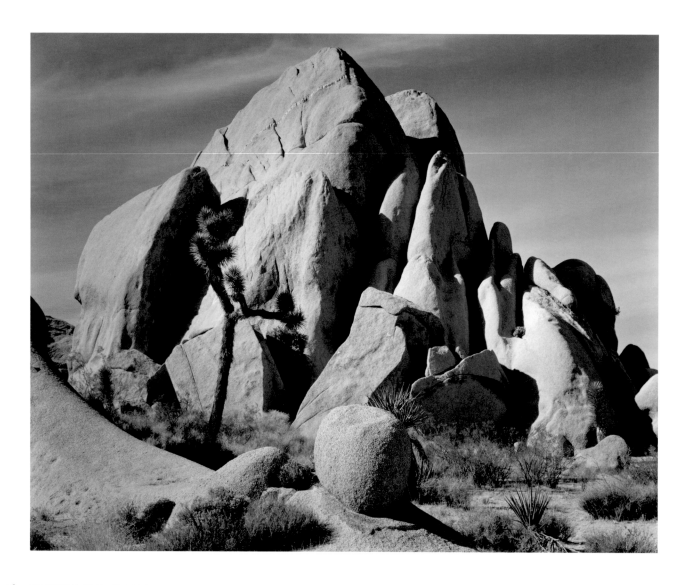

28 IN JOSHUA TREE NATIONAL MONUMENT,
CALIFORNIA
1942

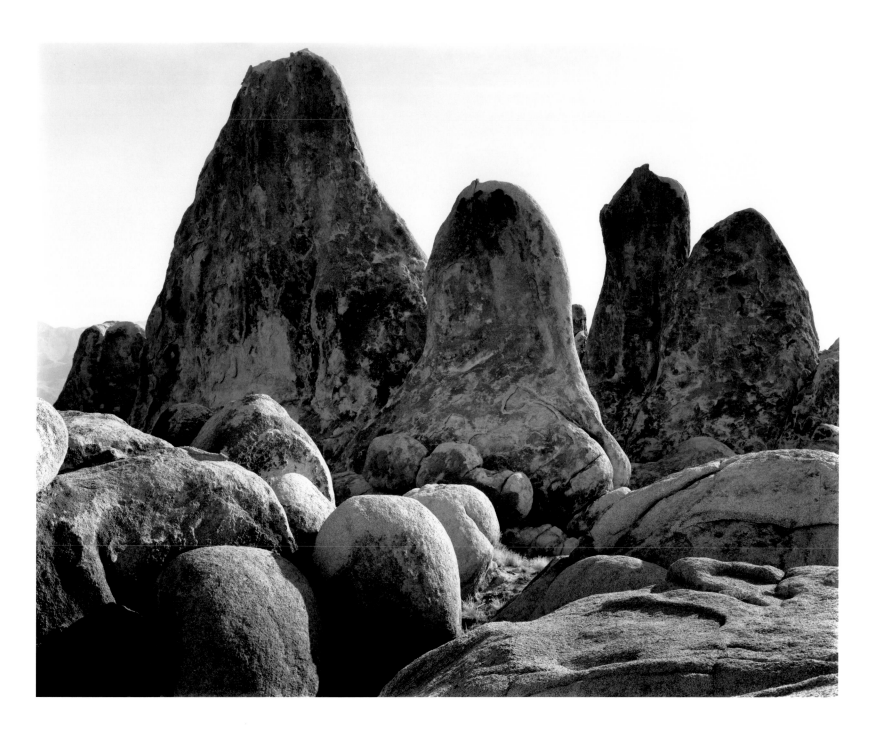

29 ROCKS,
ALABAMA HILLS
CA. 1935

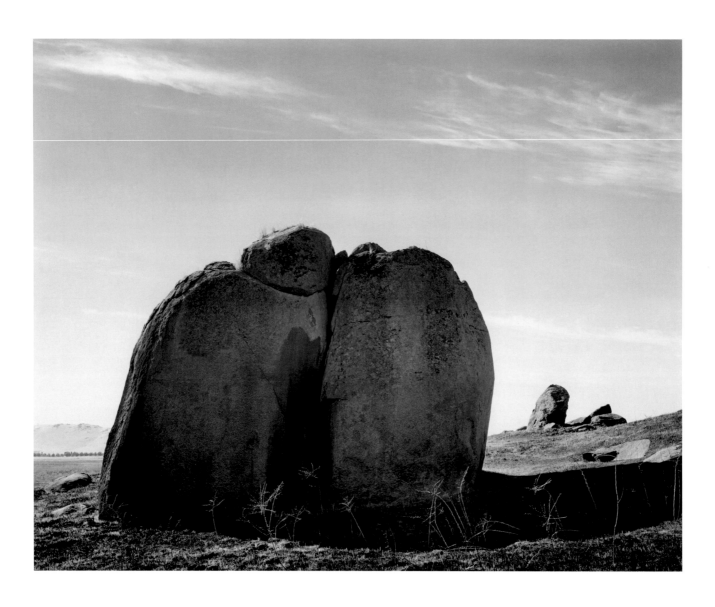

30 METAMORPHIC ROCKS,
 SIERRA FOOTHILLS
 CA. 1945

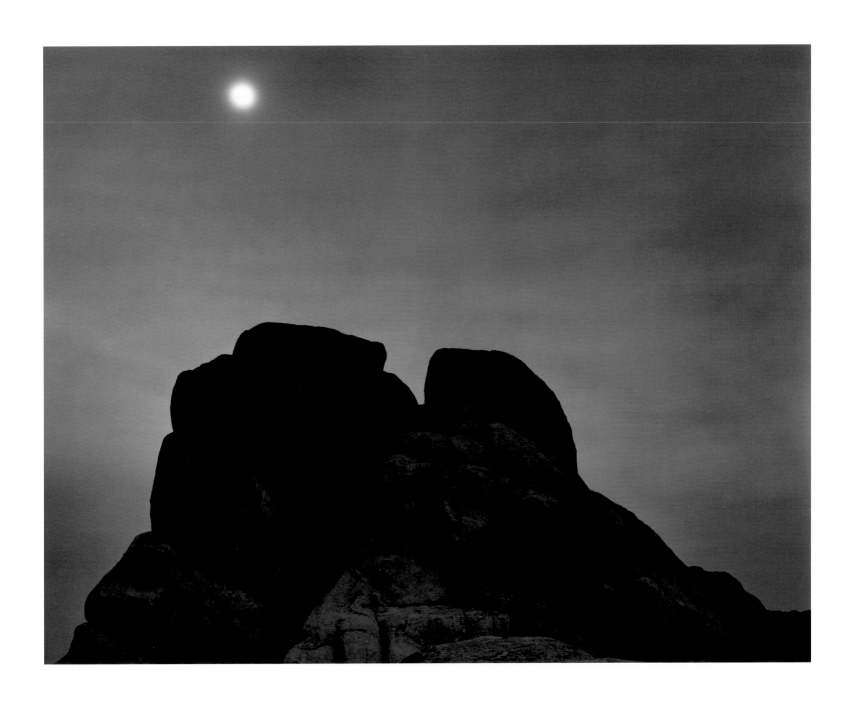

31 MOON AND ROCK,
JOSHUA TREE NATIONAL MONUMENT
1948

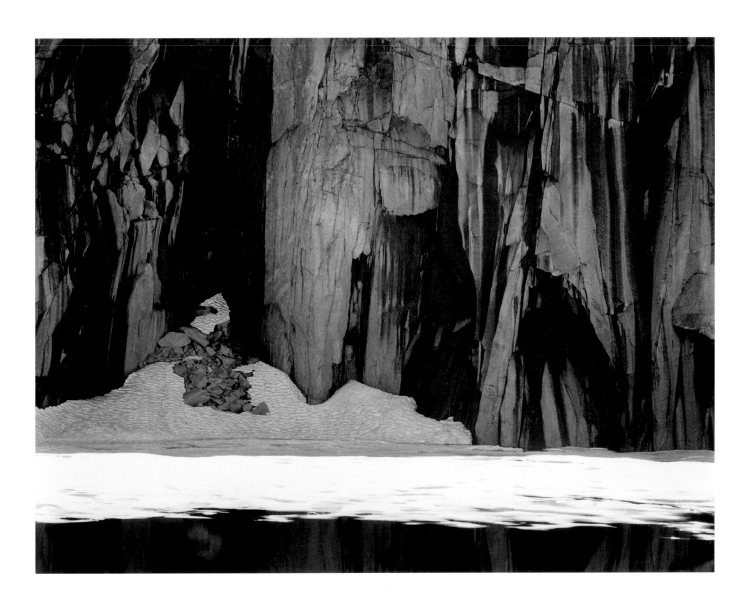

32 LAKE AND CLIFFS,
 SIERRA NEVADA
 1932

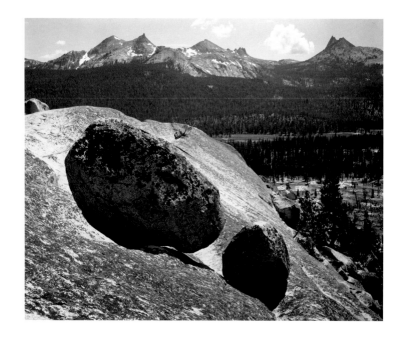

33 GLACIAL BOULDERS, CATHEDRAL RANGE,
 YOSEMITE NATIONAL PARK, CALIFORNIA
 CA. 1936

34 BASE OF WEST ARCH,
 RAINBOW BRIDGE NATIONAL MONUMENT, UTAH
 1942

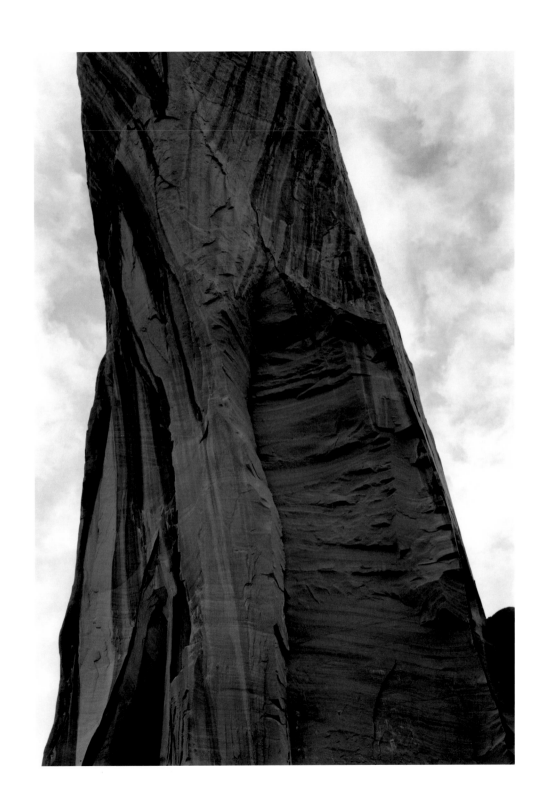

35 DEAD TREES, WINTER,
NEAR CARSON CITY, NEVADA
1960

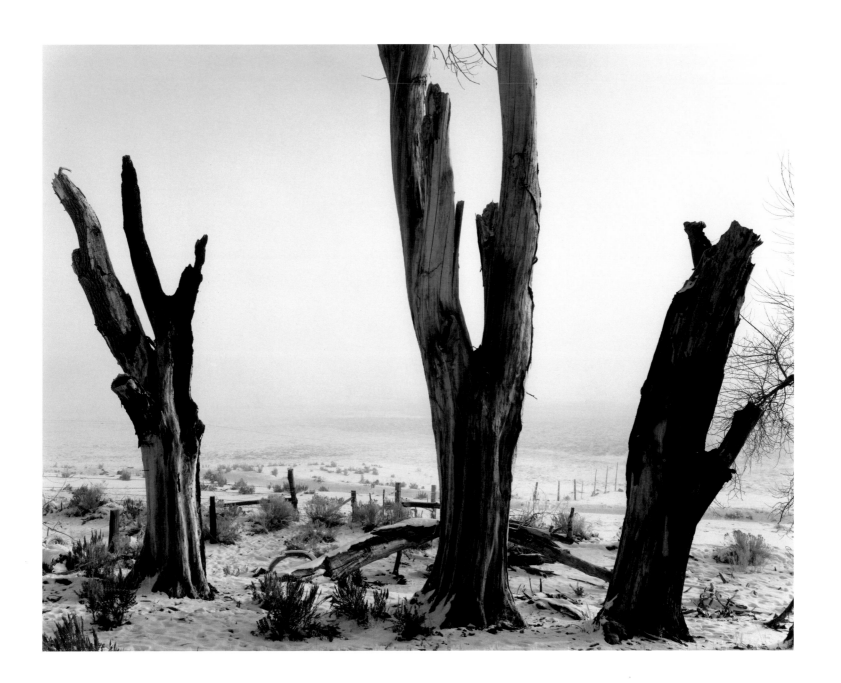

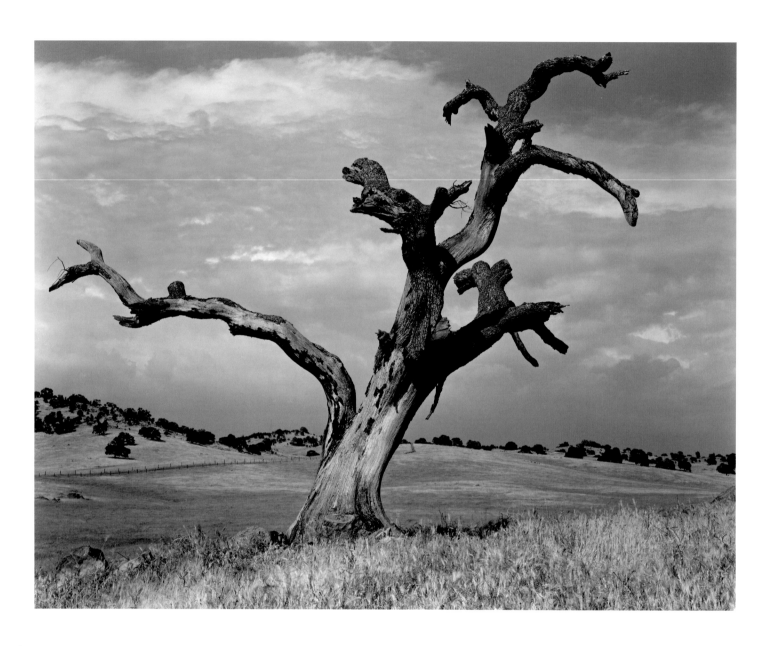

36 DEAD OAK TREE,
 SIERRA FOOTHILLS, ABOVE SNELLING
 1938

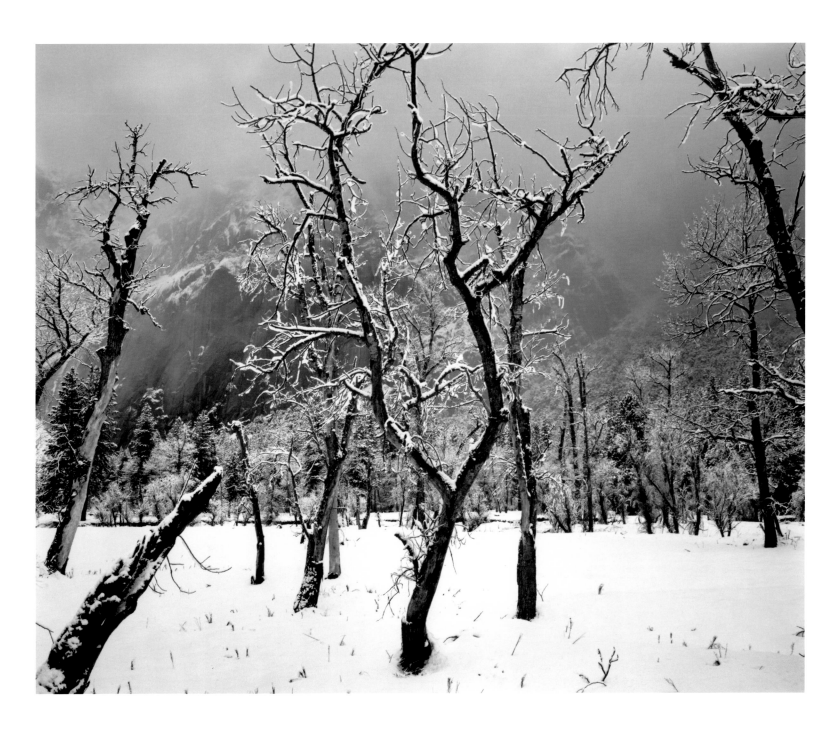

37 TREES, WINTER EVENING,
 YOSEMITE VALLEY
 N.D.

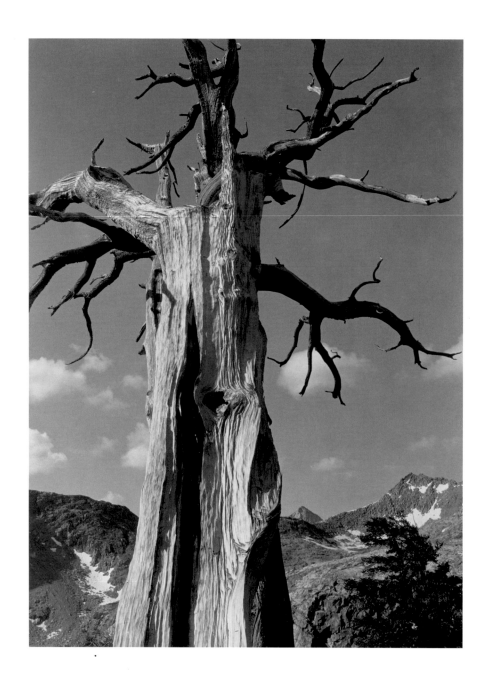

38 IN THE SIERRA NEVADA
 CA. 1932

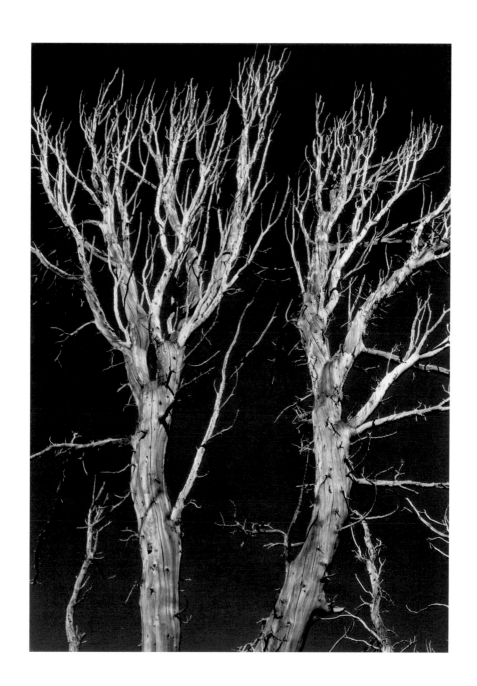

39 TWO DEAD TREES AGAINST BLACK SKY,
SIERRA NEVADA
1925

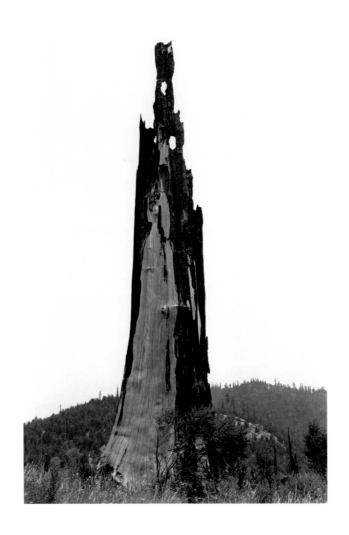

40 SNAG NEAR SCOTIA,
 CALIFORNIA
 N.D.

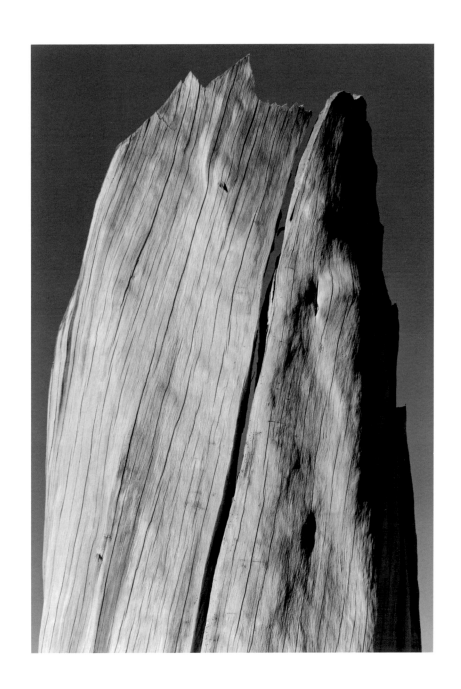

41 DEAD TREE STUMP,
 SIERRA NEVADA, CALIFORNIA
 1936

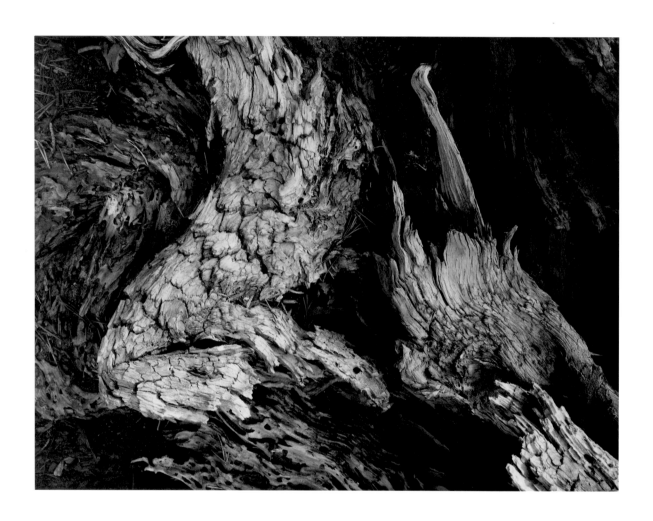

42 TREE DETAIL, STUMP WITH BIRDWING SHAPE
 N.D.

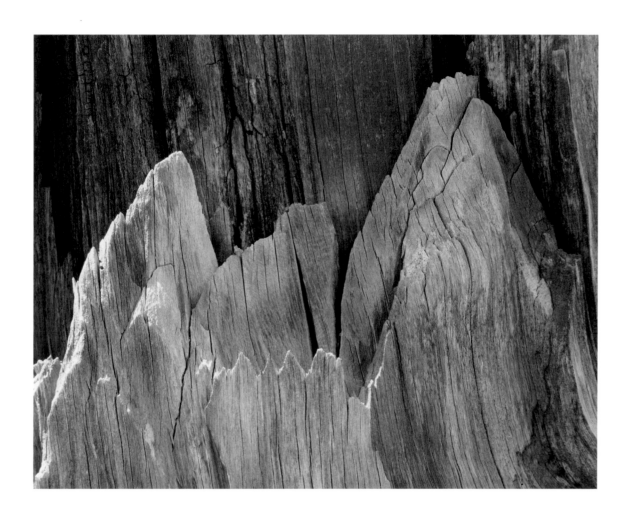

43 TREE DETAIL,
 SIERRA NEVADA
 1936

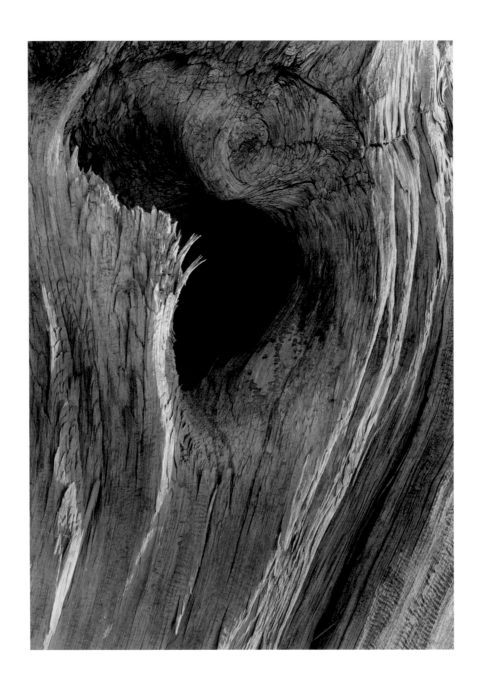

44 WOOD DETAIL, ERODED STUMP WITH KNOTHOLE
N.D.

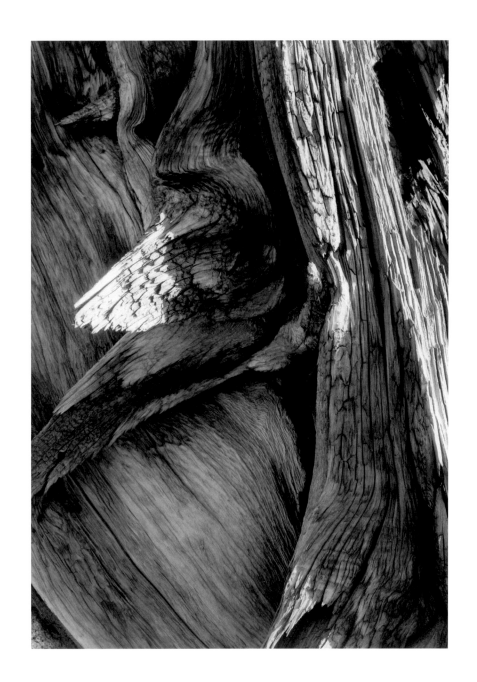

45 DETAIL JUNIPER WOOD,
SIERRA NEVADA, CALIFORNIA
CA. 1927

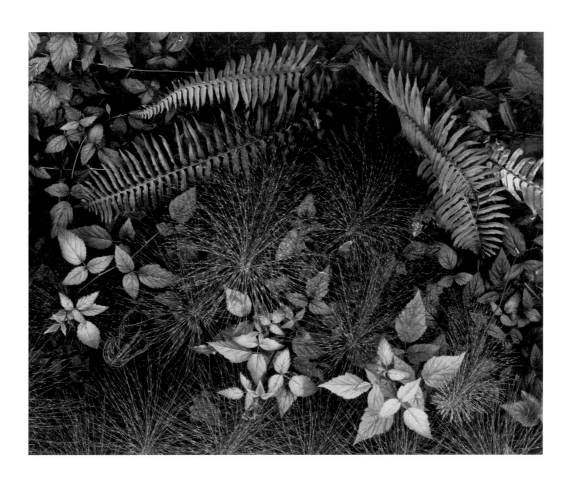

46 LEAVES, SCREEN SUBJECT,
MILLS COLLEGE, CALIFORNIA
CA. 1931

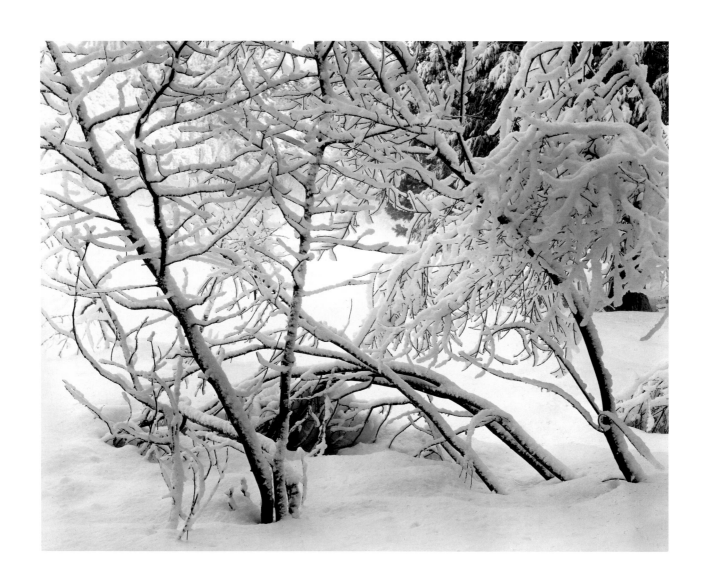

47 LOCUST TREES IN SNOW,
YOSEMITE VALLEY
CA. 1929

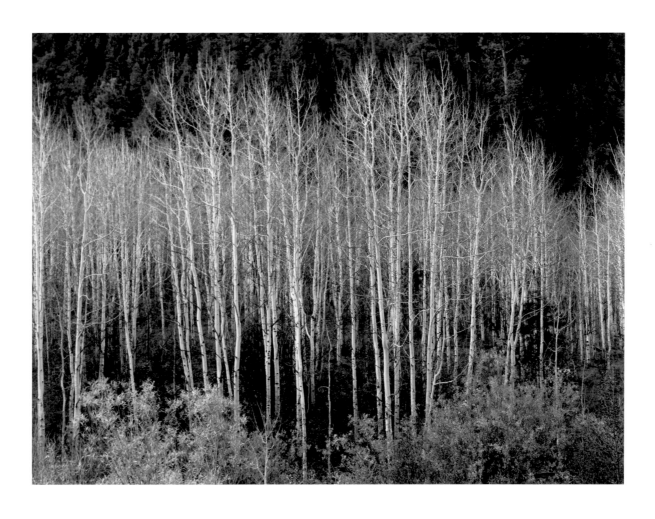

48 ASPENS, DAWN,
DOLORES RIVER CANYON, COLORADO
1937

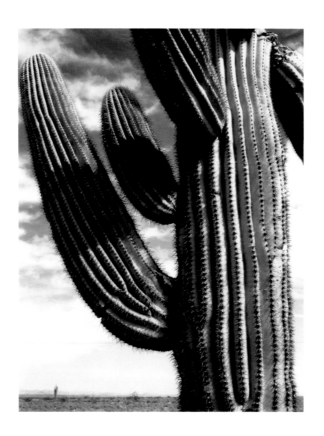

49 SAGUARO,
NEAR PHOENIX, ARIZONA
CA. 1932

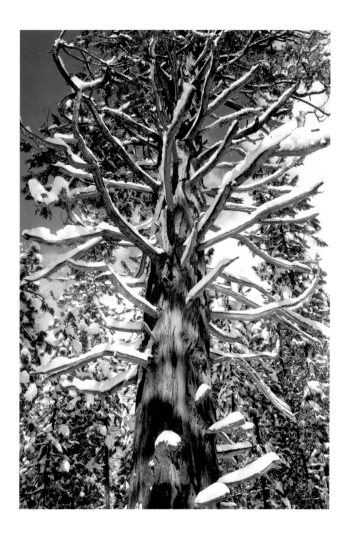

50 CEDAR TREE, WINTER,
YOSEMITE VALLEY
CA. 1935

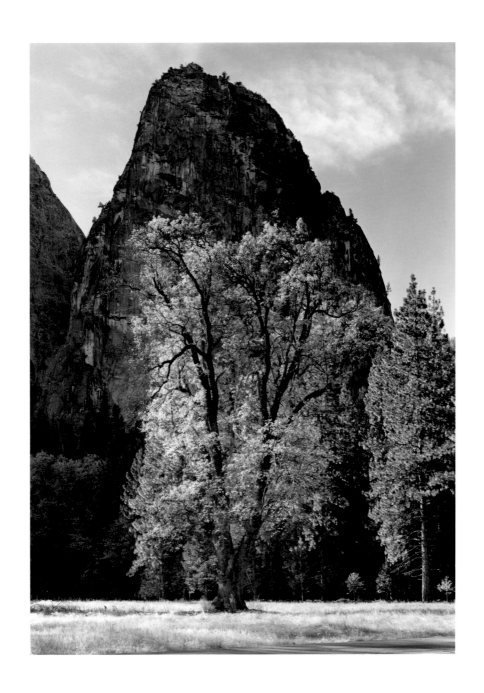

51 OAK TREE, AUTUMN,
 YOSEMITE VALLEY, CALIFORNIA
 N.D.

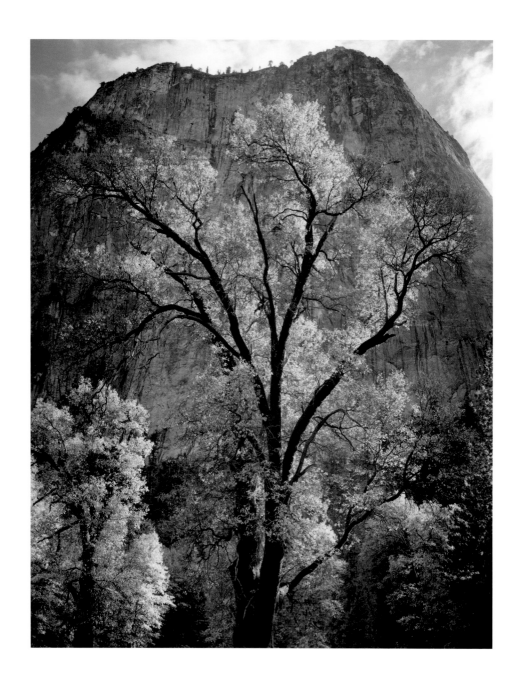

52 AUTUMN TREE AGAINST CATHEDRAL ROCKS,
YOSEMITE
CA. 1944

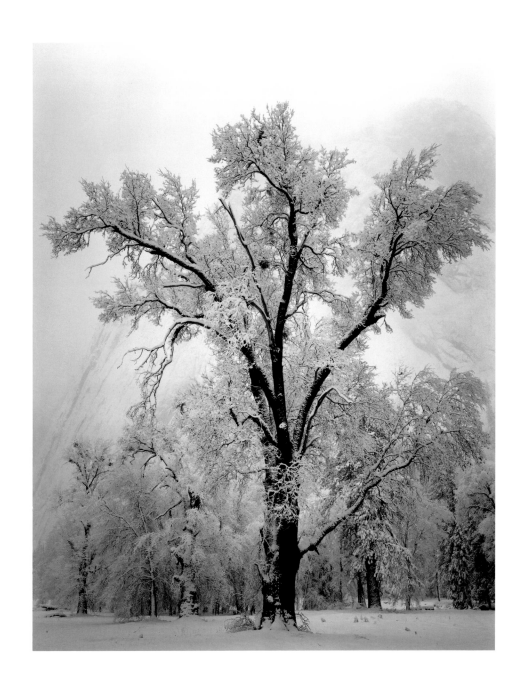

53 OAK TREE, SNOWSTORM,
YOSEMITE
1948

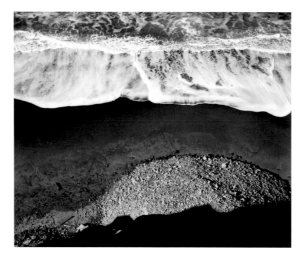
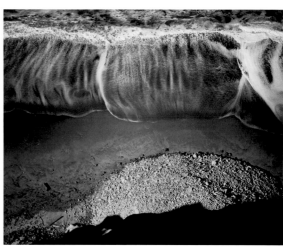

54–58 SURF SEQUENCE
1940

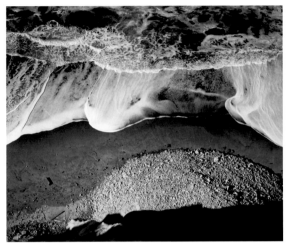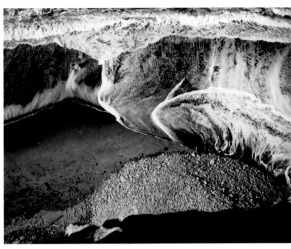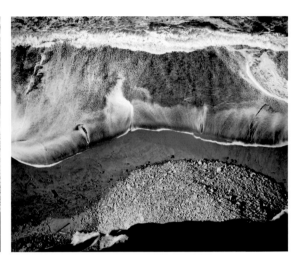

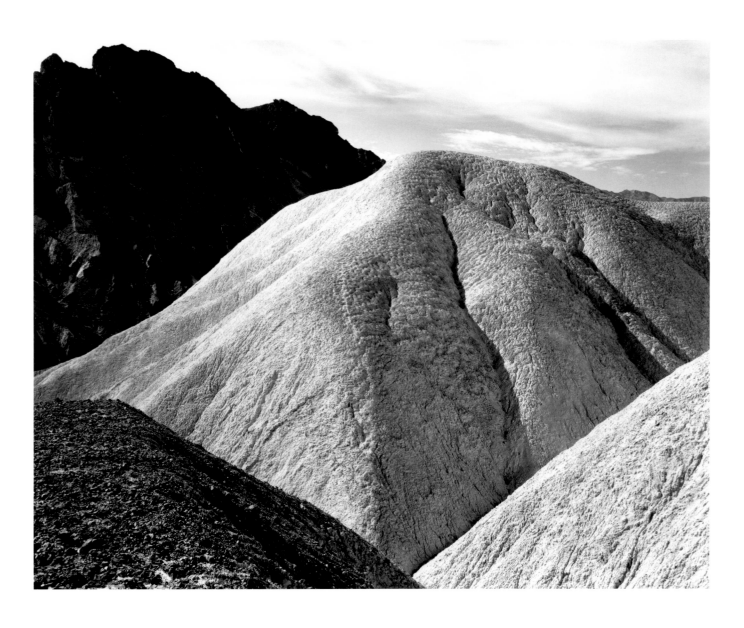

59 IN GOLDEN CANYON,
 DEATH VALLEY
 CA. 1946

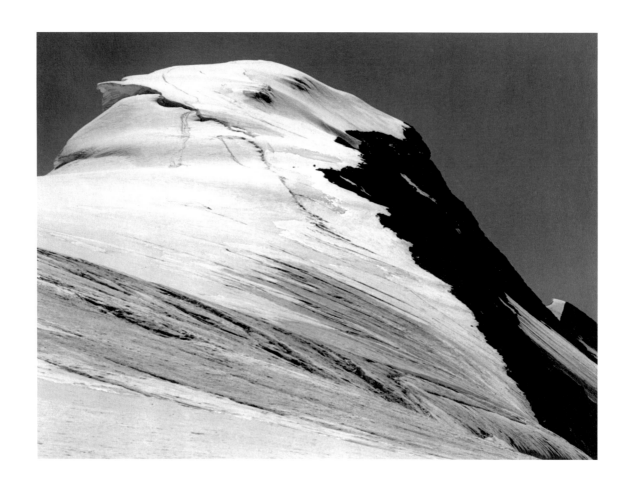

60 SUMMIT OF MOUNT RESPLENDENT,
CANADIAN ROCKIES
1928

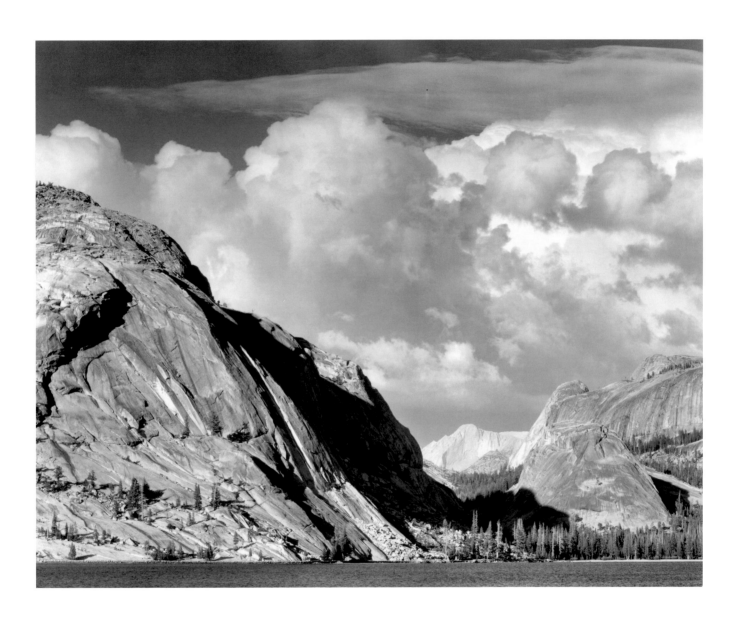

61 TENAYA LAKE, MOUNT CONNESS,
 YOSEMITE NATIONAL PARK, CALIFORNIA
 CA. 1946

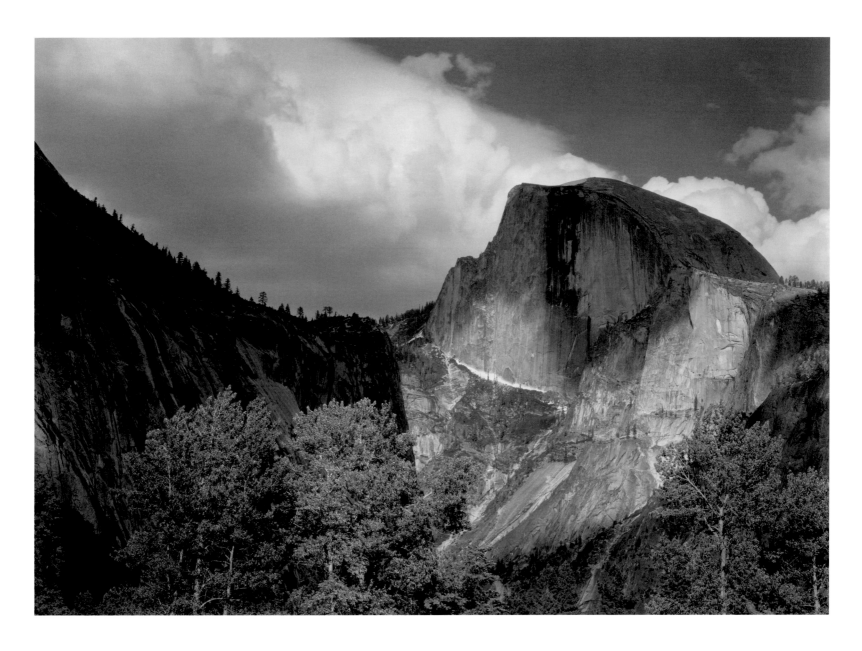

62 HALF DOME, COTTONWOOD TREES,
YOSEMITE VALLEY
CA. 1932

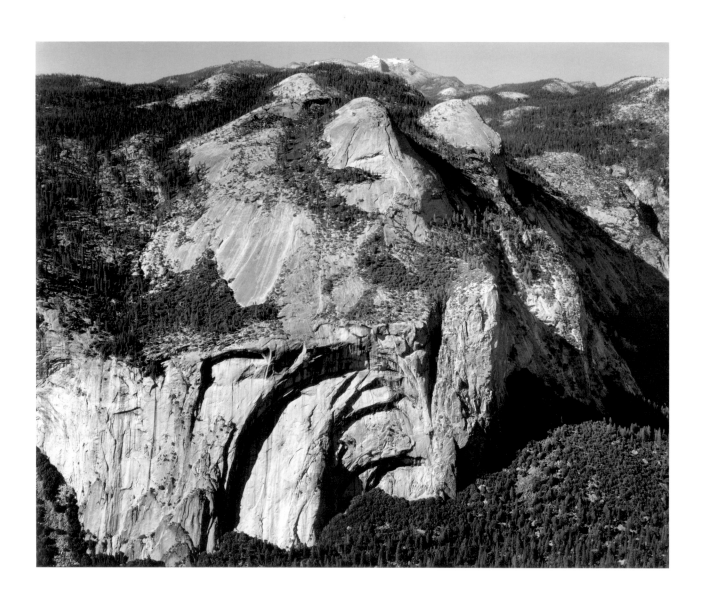

63 NORTH DOME FROM GLACIER POINT
CA. 1937

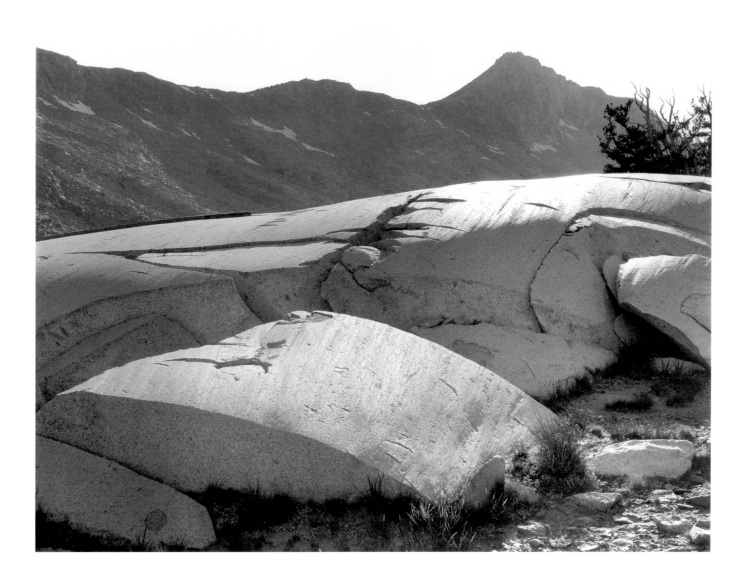

64 GLACIER POLISH, LYELL FORK OF THE MERCED RIVER,
YOSEMITE NATIONAL PARK
CA. 1935

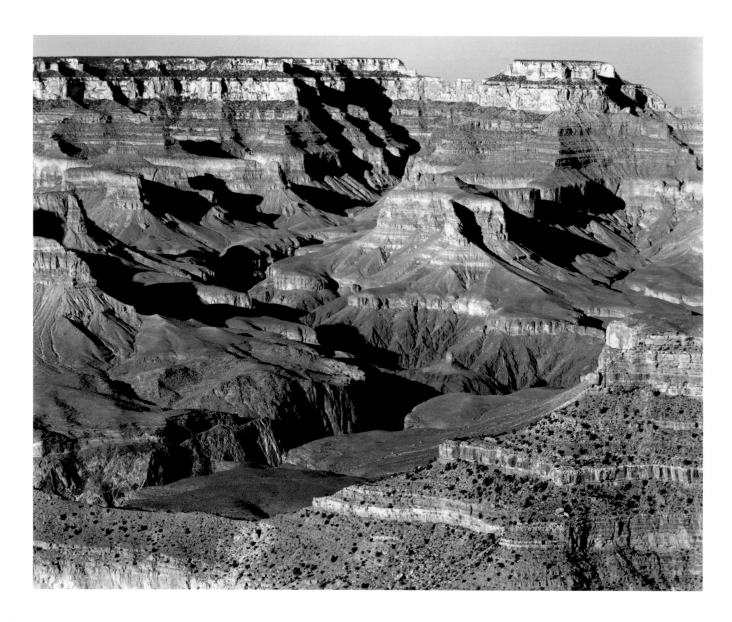

65 GRAND CANYON NATIONAL PARK,
FROM YAVAPAI POINT
1942

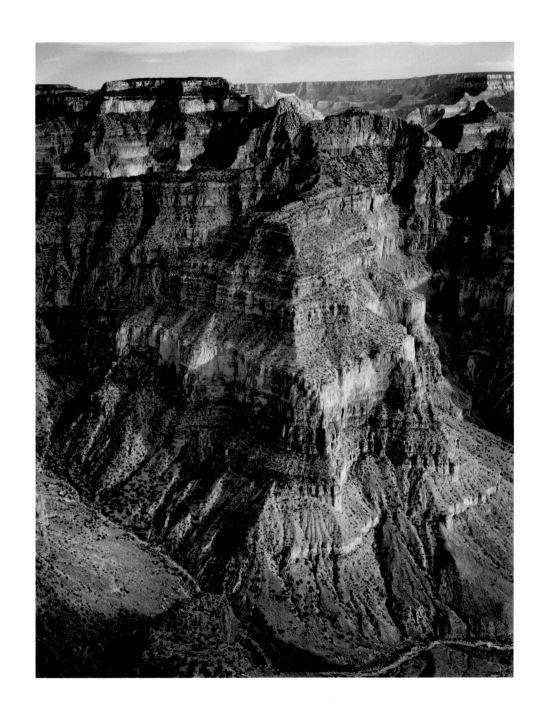

66 GRAND CANYON NATIONAL PARK,
FROM POINT SUBLIME
1942

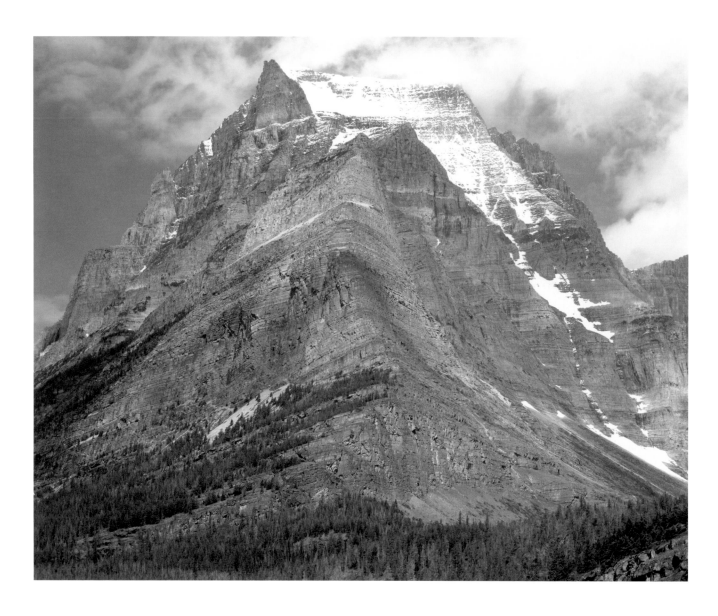

67 GOING TO THE SUN MOUNTAINS,
GLACIER NATIONAL PARK
1941–42

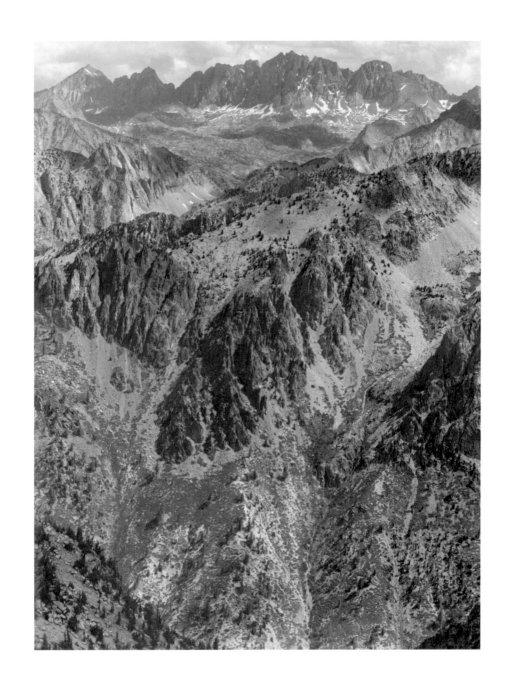

68 NORTH PALISADES, FROM WINDY POINT,
KINGS RIVER CANYON
1936

69 TRAILSIDE,
NEAR JUNEAU, ALASKA
1947

70 GRASS (SEQUENCE),
 YOSEMITE VALLEY
 1944

71 GRASS (SEQUENCE),
 YOSEMITE VALLEY
 1944

72 LAKE MC DONALD,
GLACIER NATIONAL PARK, MONTANA
1942

73 LAKE MCDONALD,
GLACIER NATIONAL PARK, MONTANA
1942

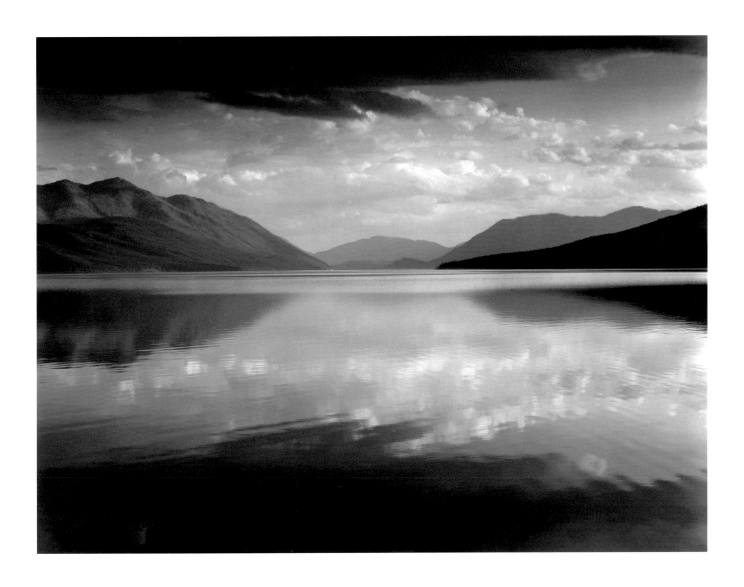

74 LAKE MC DONALD,
GLACIER NATIONAL PARK, MONTANA
1942

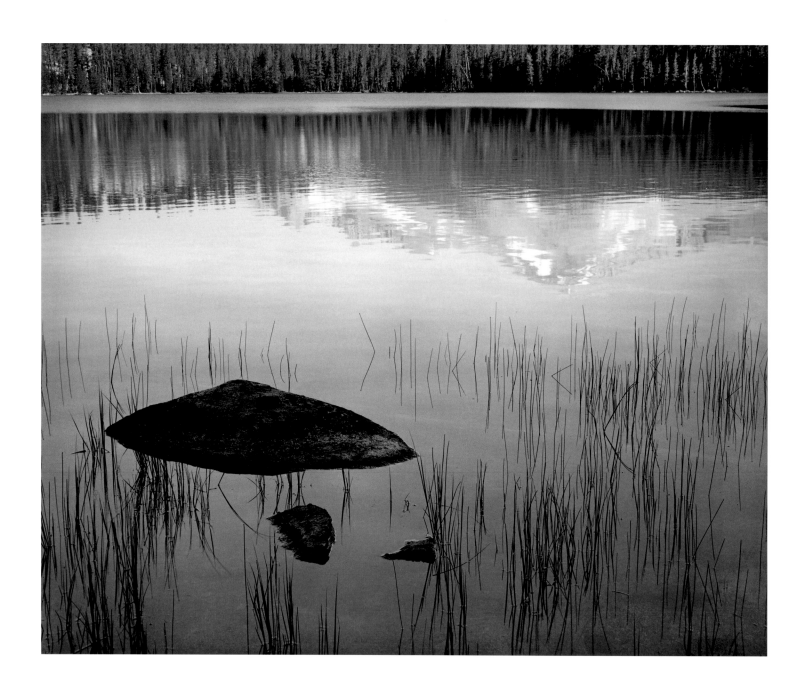

75 ROCKS AND GRASS, MORAINE LAKE,
SEQUOIA NATIONAL PARK, CALIFORNIA
1936

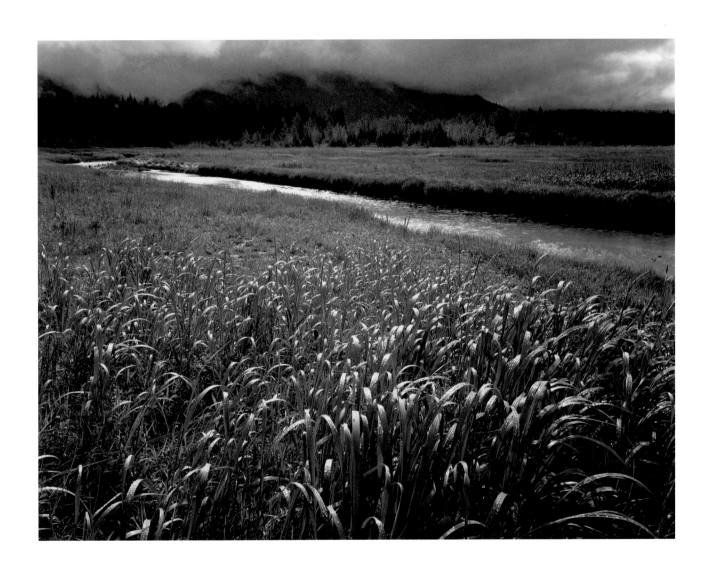

76 RAIN, BEARTRACK COVE,
 GLACIER BAY NATIONAL MONUMENT, ALASKA
 1949

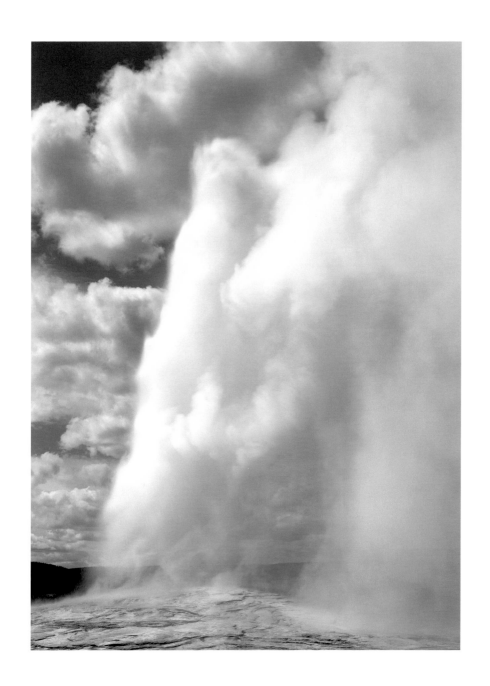

77 OLD FAITHFUL,
YELLOWSTONE NATIONAL PARK
1941–42

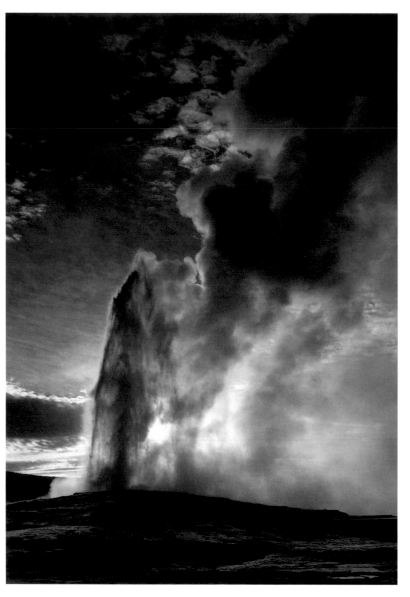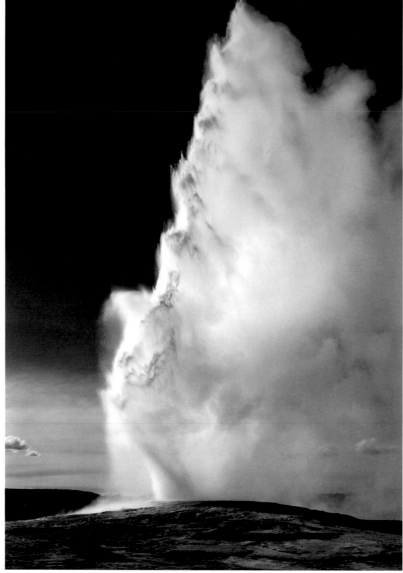

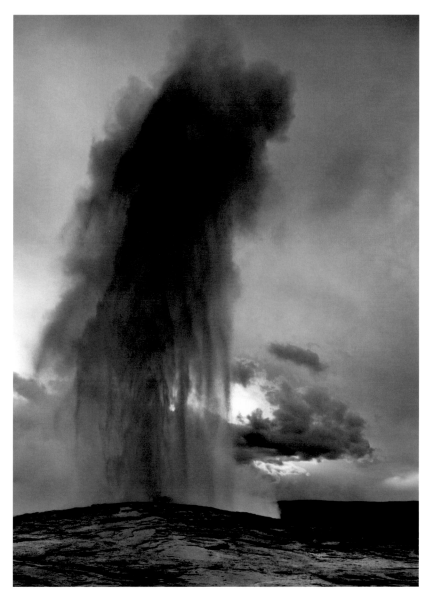
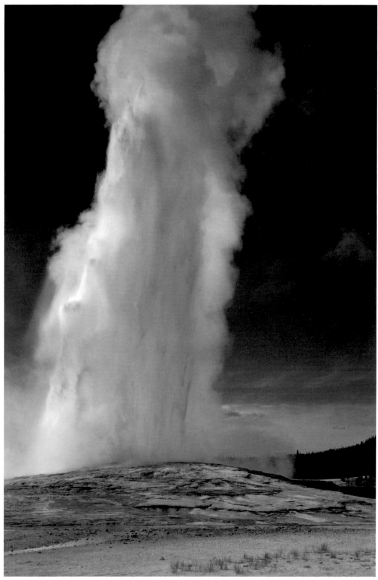

78–81 OLD FAITHFUL GEYSER,
YELLOWSTONE NATIONAL PARK, WYOMING
1942

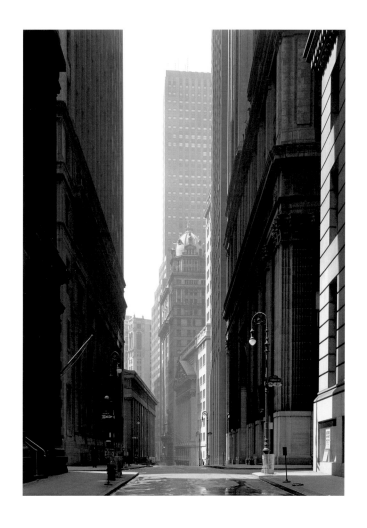

82 BROAD STREET,
 NEW YORK CITY
 CA. 1949

83 THUNDERCLOUD, ELLERY LAKE,
 HIGH SIERRA, CALIFORNIA
 1934

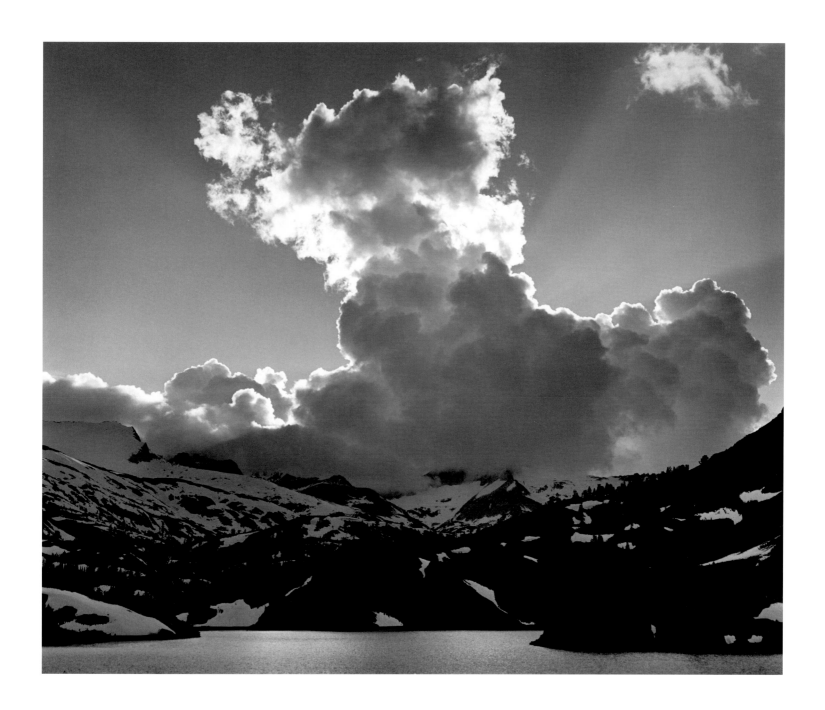

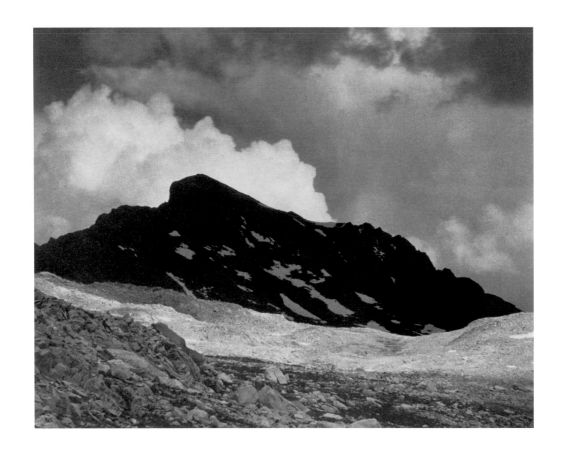

84 THE BLACK GIANT, MUIR PASS,
REPRODUCED FROM "SIERRA NEVADA: THE JOHN MUIR TRAIL"
CA. 1934

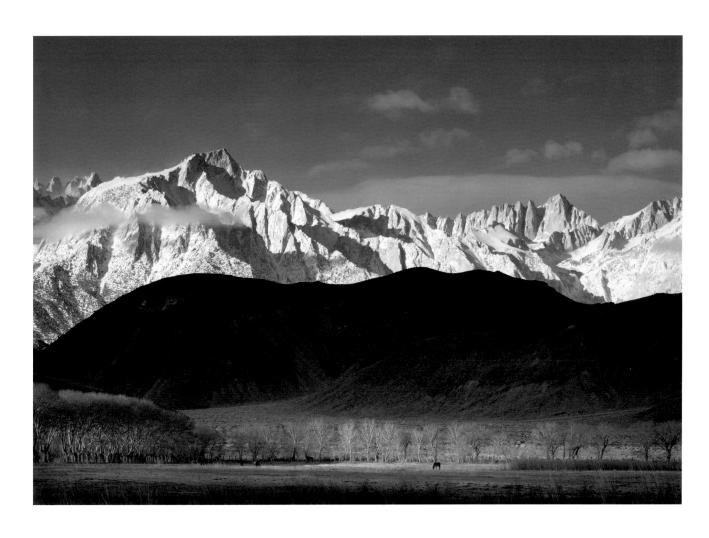

85 WINTER SUNRISE,
 SIERRA NEVADA FROM LONE PINE, CALIFORNIA
 1944

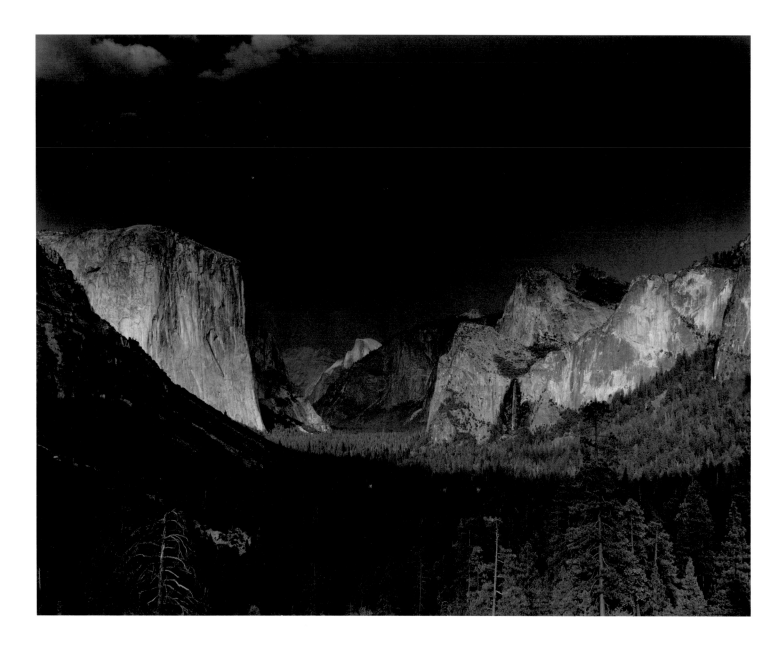

86 YOSEMITE VALLEY,
CLEARING THUNDERSTORM FROM TUNNEL ESPLANADE, CALIFORNIA
CA. 1972

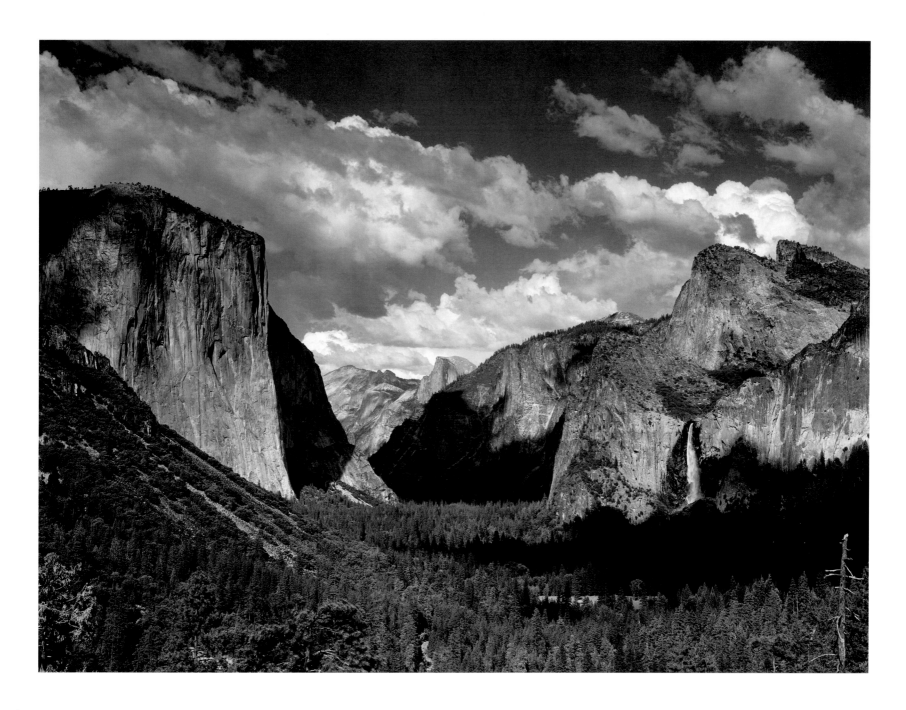

87 YOSEMITE VALLEY,
YOSEMITE NATIONAL PARK
CA. 1935

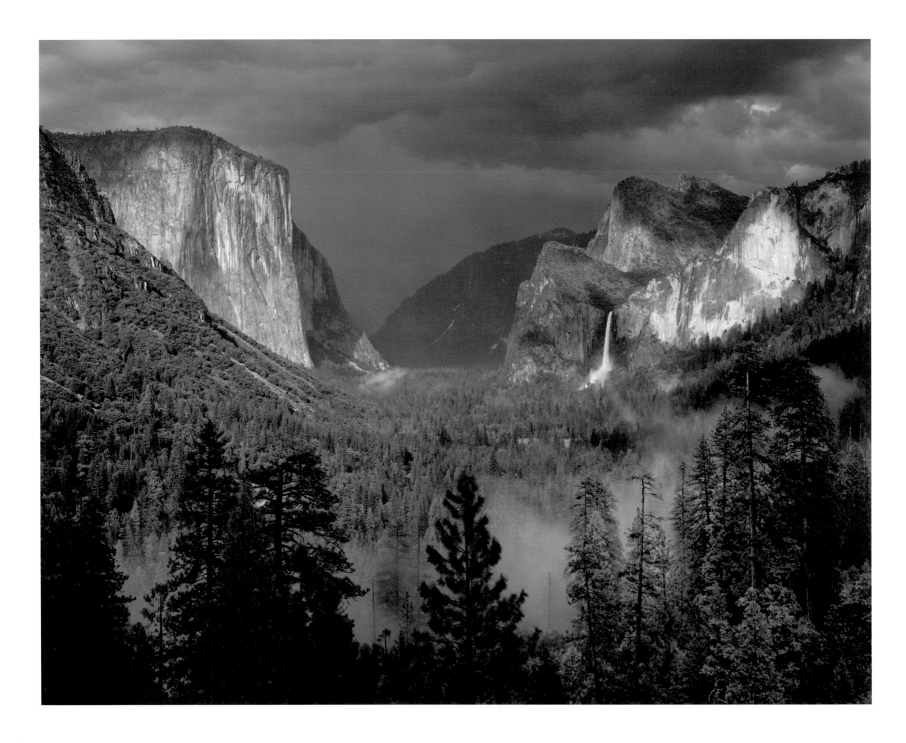

88 YOSEMITE VALLEY, THUNDERSTORM
CA. 1949

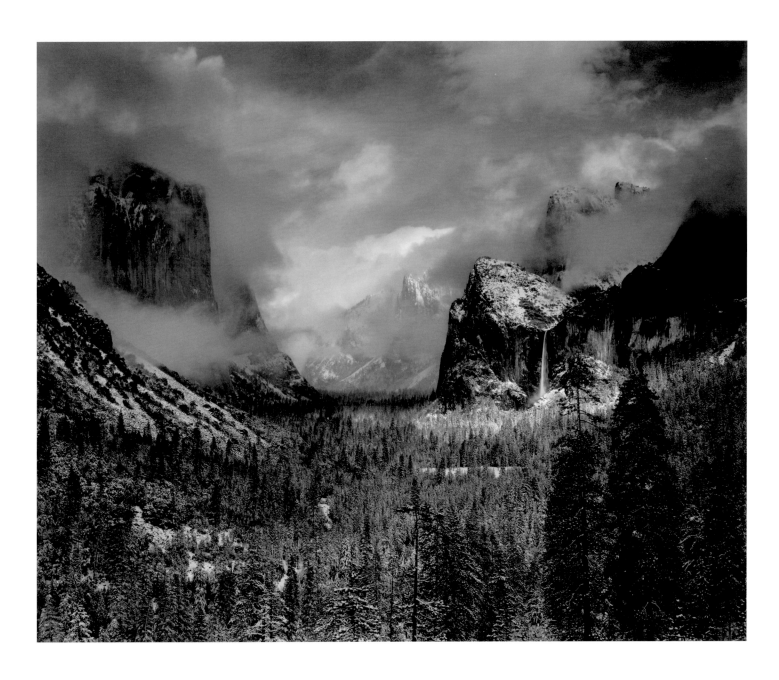

89 CLEARING WINTER STORM,
 YOSEMITE VALLEY, CALIFORNIA
 1942 OR EARLIER

90 FLOWERS AND ROCK,
SAN JOAQUIN SIERRA
1936

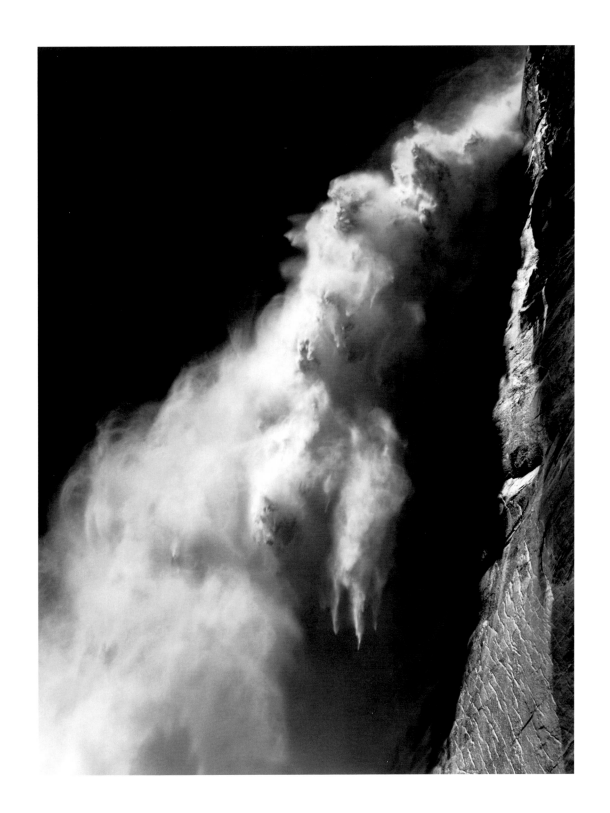

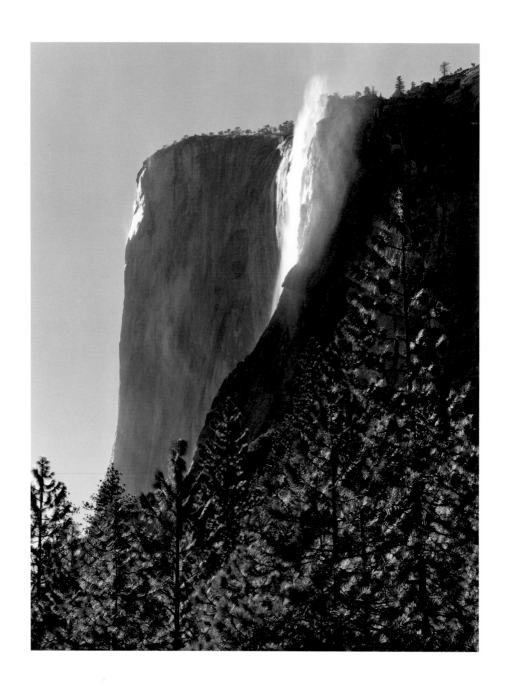

92 EL CAPITAN FALL,
 YOSEMITE VALLEY
 N.D.

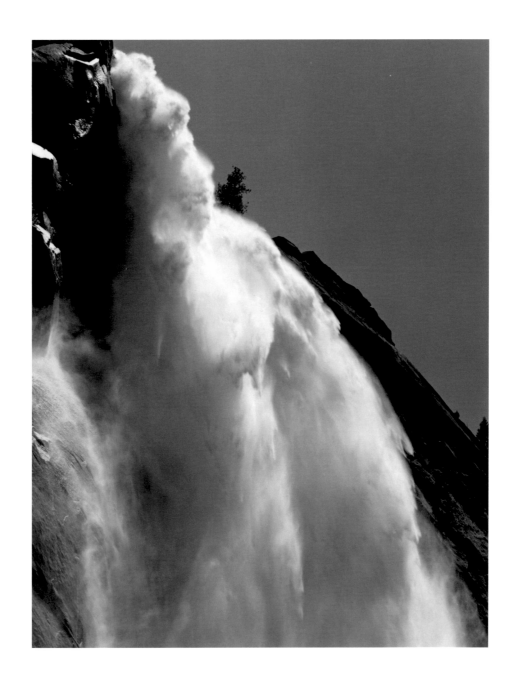

93 NEVADA FALL,
 YOSEMITE NATIONAL PARK, CALIFORNIA
 CA. 1946

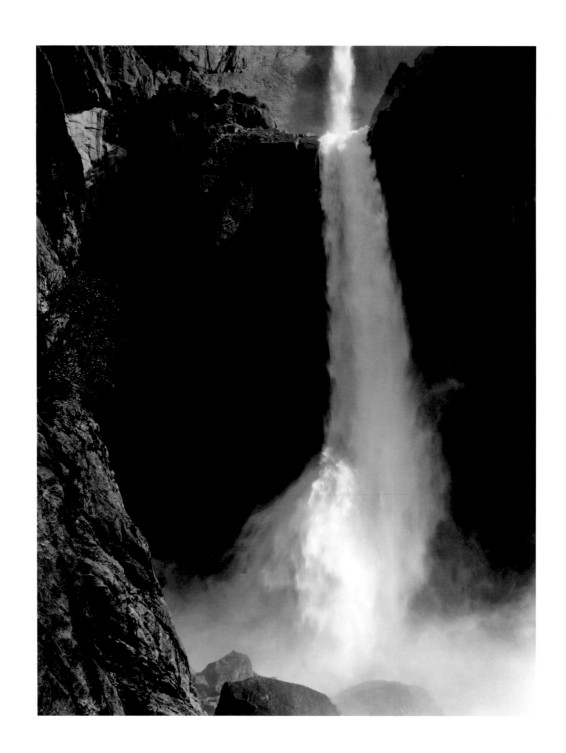

94　LOWER YOSEMITE FALL,
YOSEMITE VALLEY, CALIFORNIA
CA. 1946

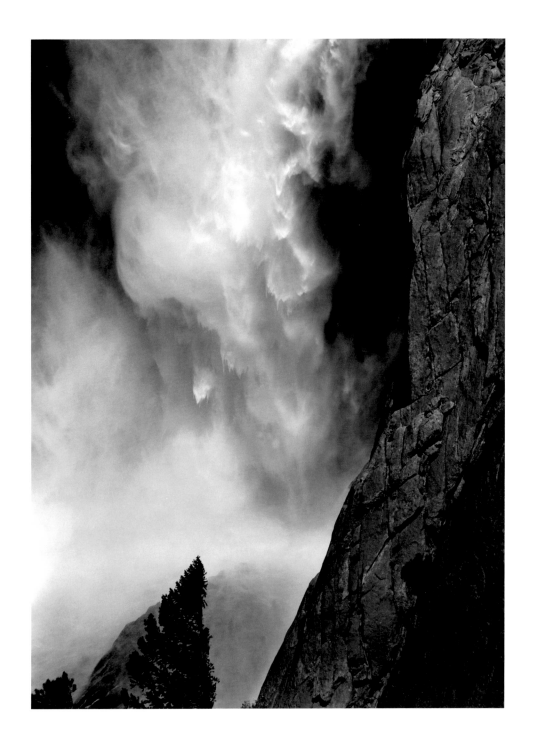

95 BASE OF UPPER YOSEMITE FALL,
YOSEMITE NATIONAL PARK
CA. 1950

96 MOONRISE,
HERNANDEZ, NEW MEXICO
1941

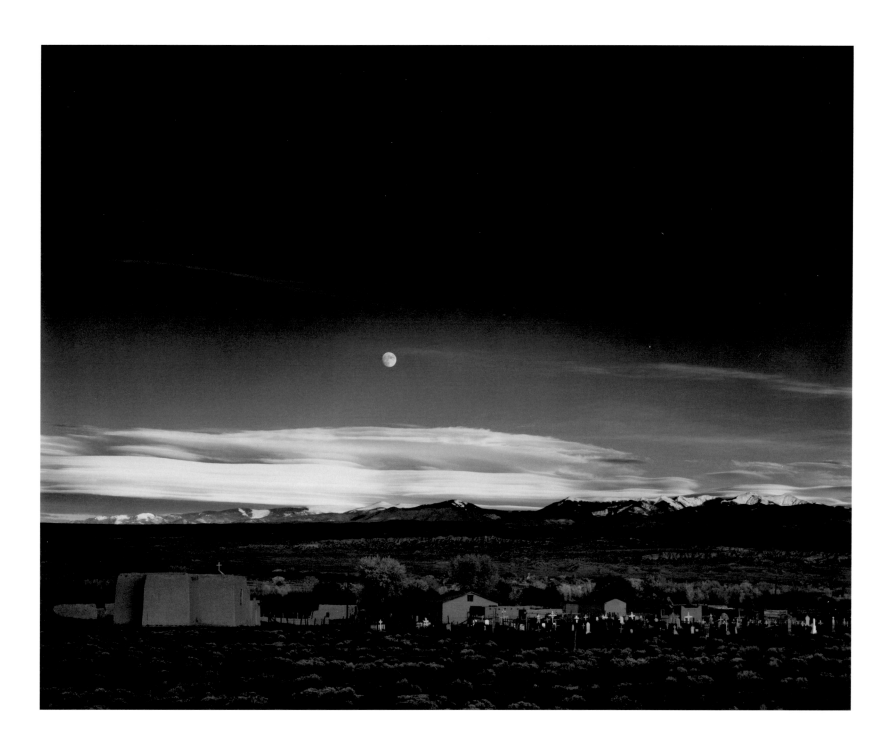

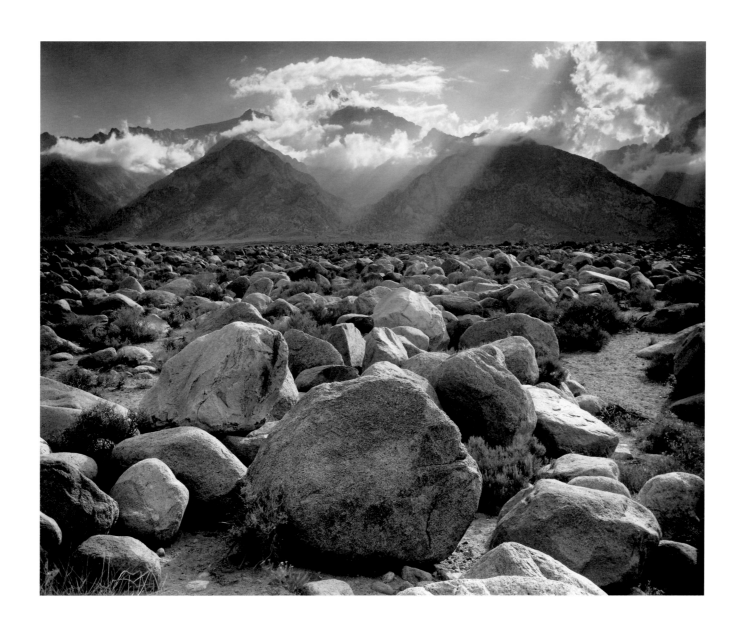

97 MOUNT WILLIAMSON,
 SIERRA NEVADA, FROM MANZANAR, CALIFORNIA
 CA. 1944

98 LATE AUTUMN EVENING, MERCED RIVER CANYON,
YOSEMITE NATIONAL PARK
CA. 1947

99 EARLY MORNING, MERCED RIVER,
 YOSEMITE VALLEY, CALIFORNIA
 CA. 1950

100 CYPRESS AND FOG,
 PEBBLE BEACH, CALIFORNIA
 1967

101 STUMP, TRINIDAD HEAD,
NORTHERN CALIFORNIA
1966

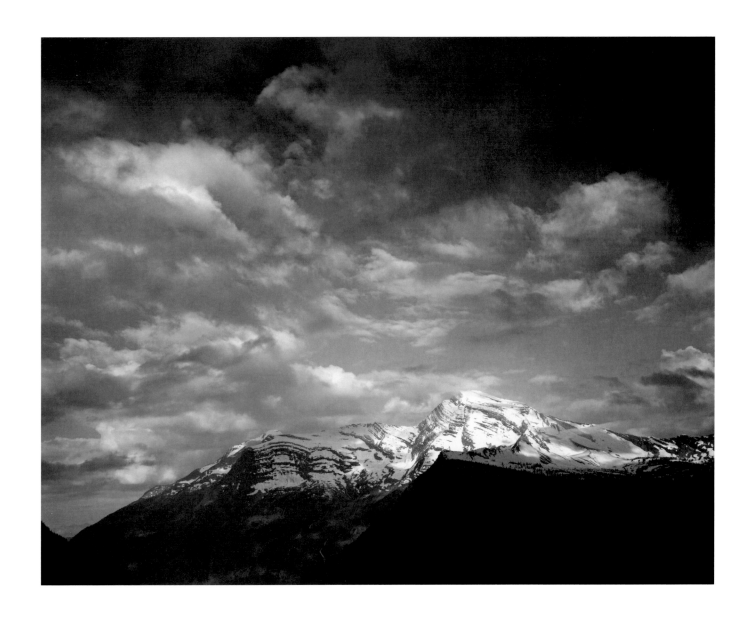

102 HEAVEN'S PEAK
1941–42

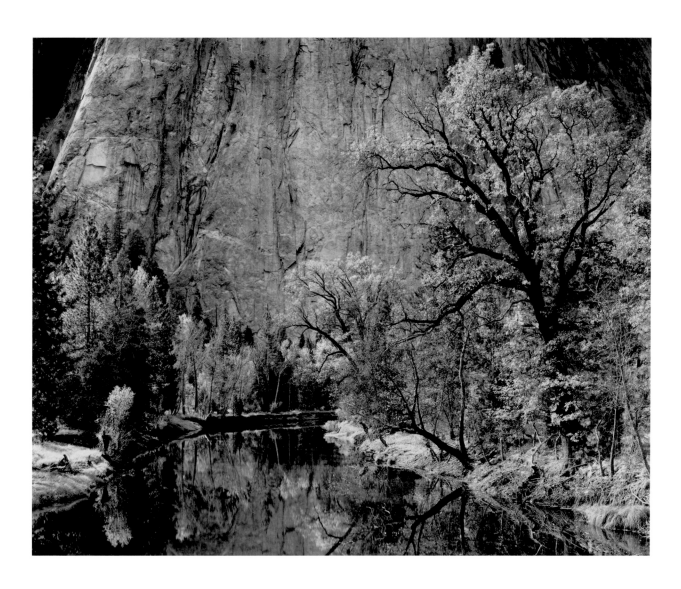

103 MERCED RIVER, CLIFFS OF CATHEDRAL ROCKS, AUTUMN,
FROM "PORTFOLIO III: YOSEMITE VALLEY"
1939

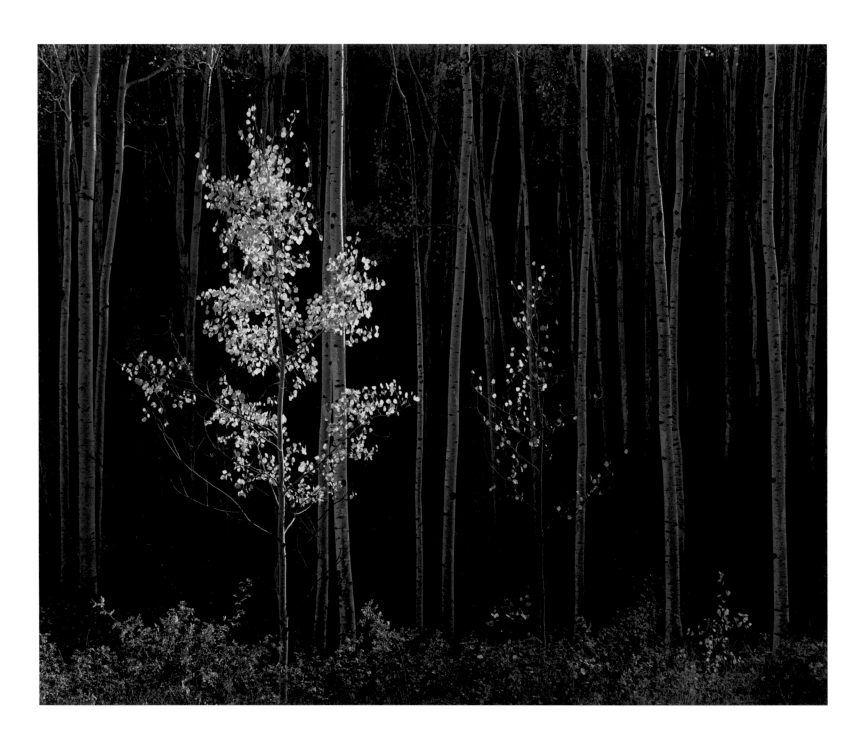

104 ASPENS,
NORTHERN NEW MEXICO
1958 (PRINT 1958–60)

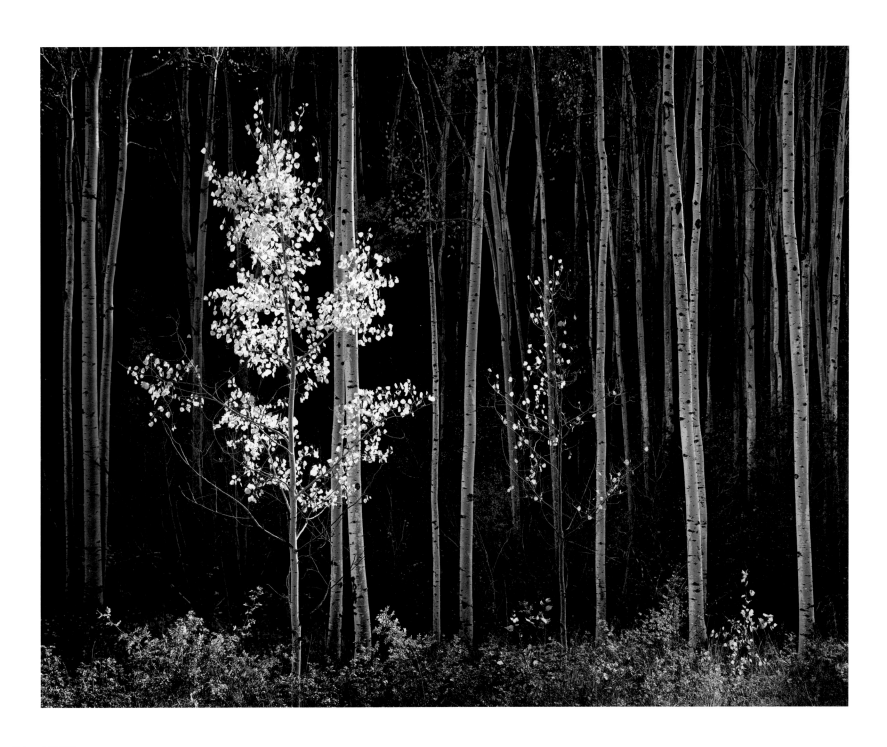

105 ASPENS,
NORTHERN NEW MEXICO
1958 (PRINT 1976)

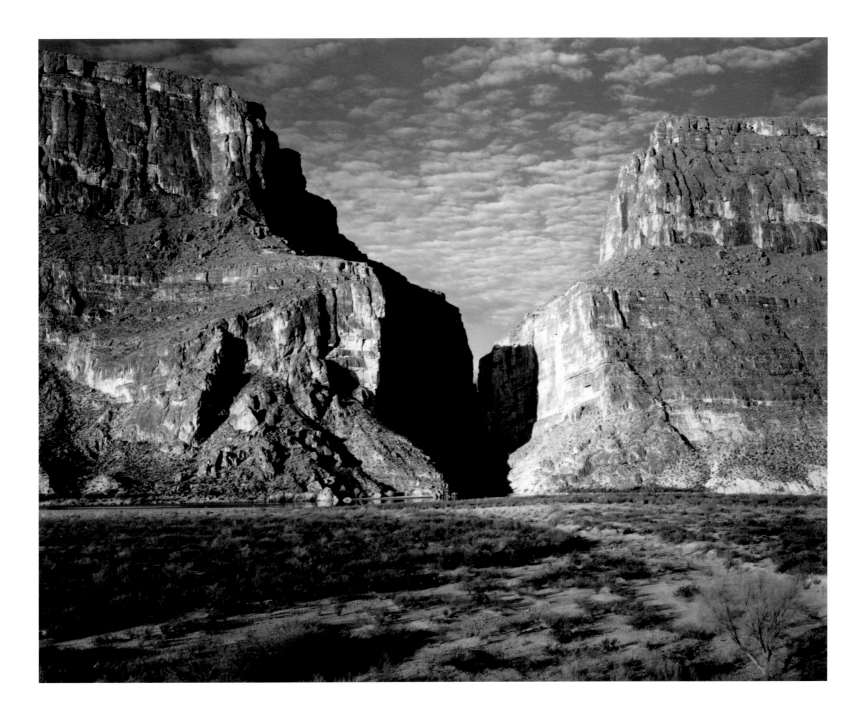

106 SANTA ELENA CANYON,
BIG BEND NATIONAL PARK, TEXAS
1947

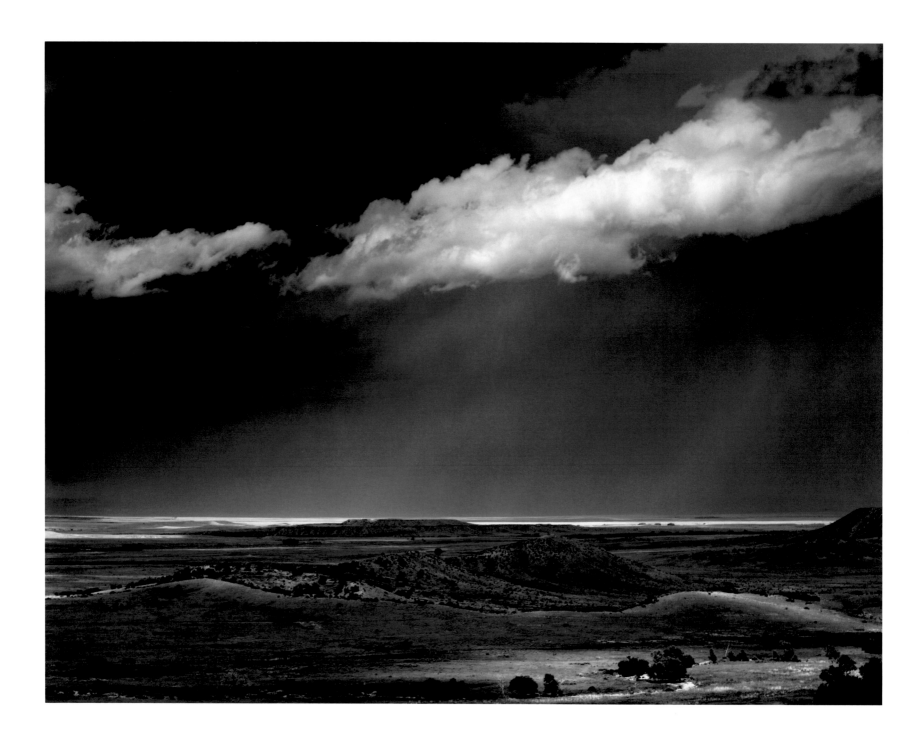

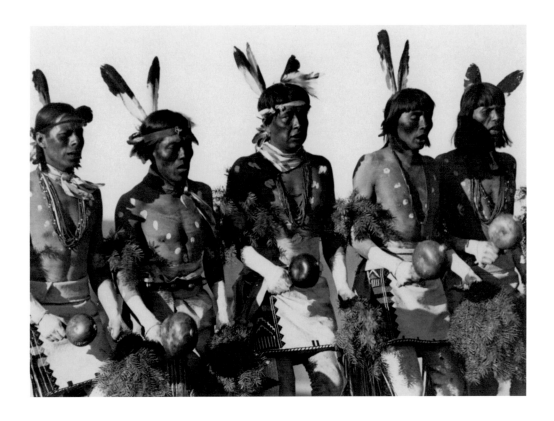

107 THUNDERSTORM OVER THE GREAT PLAINS,
NEAR CIMARRON, NEW MEXICO
1961

108 BUFFALO DANCE, SAN ILDEFONSO PUEBLO,
NEW MEXICO
1928

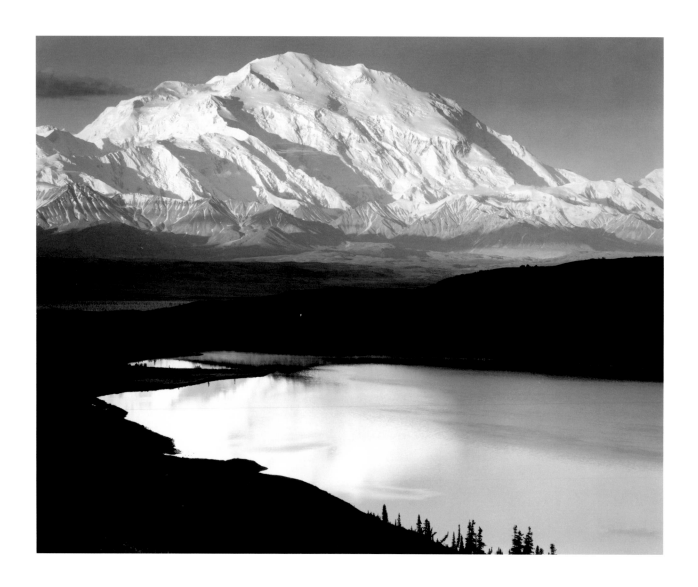

109 MOUNT MCKINLEY AND WONDER LAKE,
ALASKA
1948 (PRINT 1949)

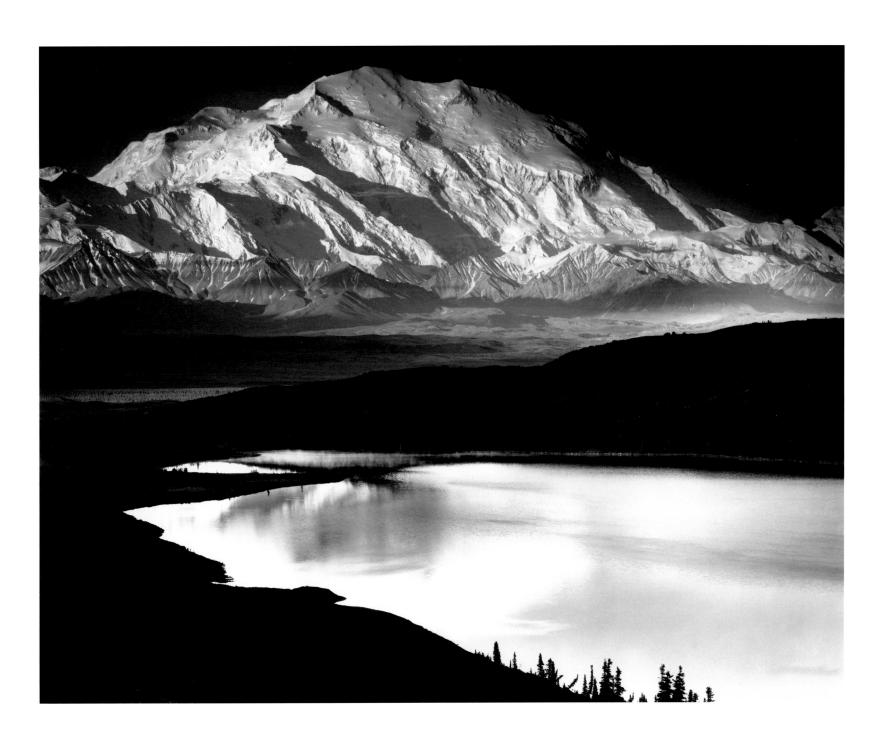

110 MOUNT MCKINLEY AND WONDER LAKE,
 MOUNT MCKINLEY NATIONAL PARK, ALASKA
 1948 (PRINT 1978)

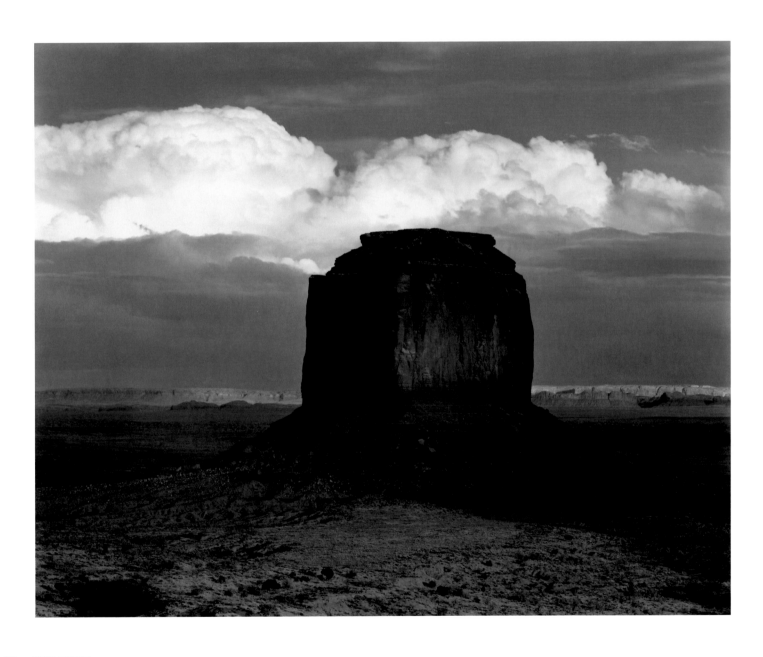

III HOPI BUTTE,
 MONUMENT VALLEY, ARIZONA
 CA. 1936

112 EL CAPITAN, MERCED RIVER, AGAINST SUN,
YOSEMITE VALLEY, CALIFORNIA
CA. 1950

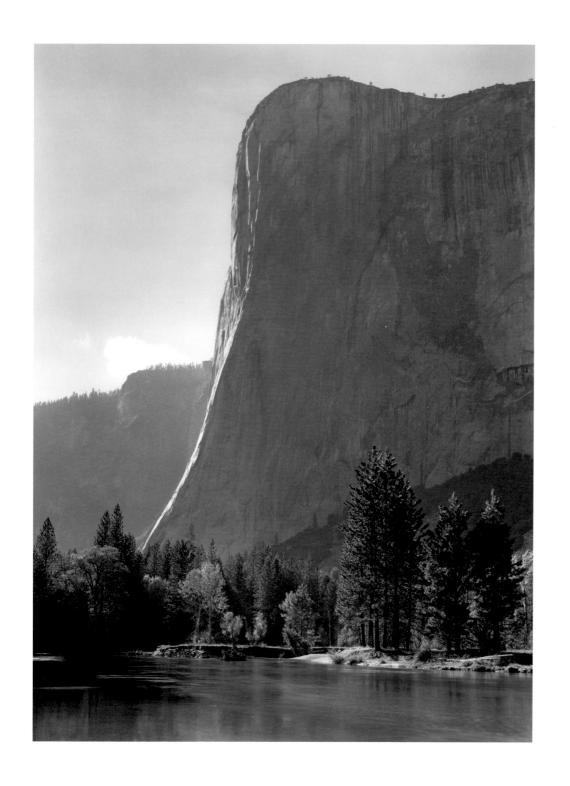

113 EL CAPITAN, SUNRISE, WINTER,
YOSEMITE NATIONAL PARK, CALIFORNIA
CA. 1968

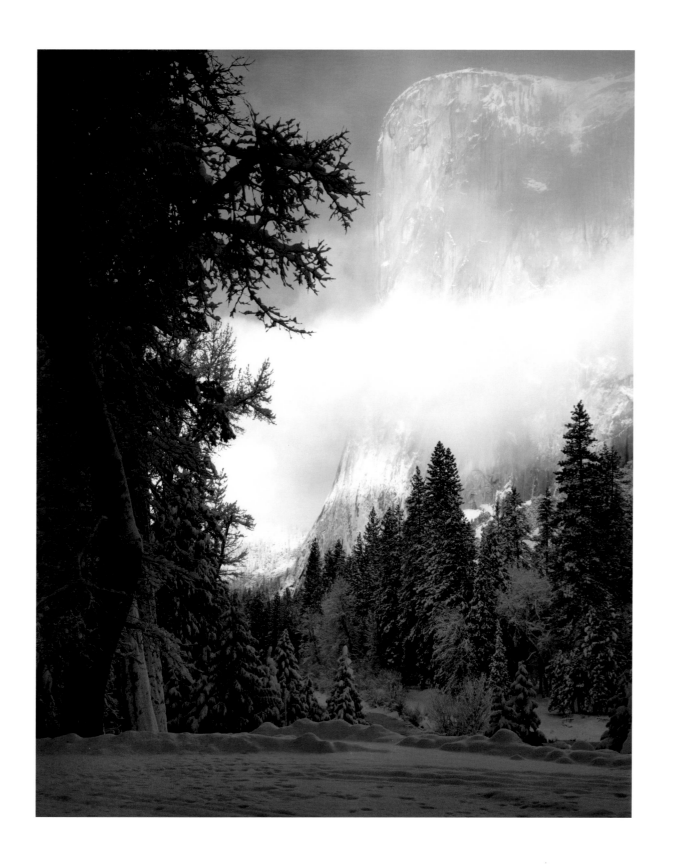

The titles and dates of photographs are notoriously undependable, largely because a photograph of some general interest is likely to be printed (finished) not once but many times. Few photographers of the modern era keep a definitive list of their pictures' titles; often the negative number provides the only dependable identification of a specific work, and the title and date are retrieved from memory each time the work is reprinted. Depending on the demands of the occasion, the picture will sometimes get a short title, and sometimes one with some amplitude. By the time a photograph becomes famous, the trail of outright error and improvised variation may be too deeply imbedded in the archives to be ever set right.

In the case of Ansel Adams the problem of dating is unusually severe, partially because Adams was not much interested. His sense of time had more to do with the quality of light than with the number of the year. His most famous picture, *Moonrise, Hernandez* (sometimes called merely *Moonrise*, and sometimes *Moonrise, Hernandez, New Mexico*), was variously dated 1940, 1941, 1942, and 1944 by Adams, until the astronomer David Elmore determined that the moon and stars were in the indicated relationship only on the last day of October 1941.

The problem is exacerbated by the fact that Adams' subjects seldom include the kind of cultural ephemera—license plates, posters, commercial architecture—that is so useful in dating pictures made in urban locales.

In these circumstances I have been reluctant to further confuse the dating problem by adding my own guesses. In general, I have accepted the dates provided by the lenders; in a few cases, when the evidence has seemed to me strong, I have added an alternative date in parentheses.

The term *vintage print* was not invented until Adams was a fairly old man, and he did not agree with the fashionable idea that earlier prints from a negative are better than later prints. In my own view Adams' earlier prints from a given negative are generally—not always—more persuasive, and the prints reproduced here were in most cases made fairly close to the time of the negative. In some cases, however, contemporary prints of important negatives have apparently disappeared into the great twentieth-century landfill. In other cases a negative may not have been printed at all until many years after it was made. Like most photographers of the modern era, Adams was far behind with his printing, and frequently lamented the lack of time to catch up. I have seen no contemporary prints, for example, of *Santa Elena Canyon* (plate 106) or *Hopi Butte* (plate 111). It would appear that these pictures were not finished until decades after the negatives were made. When a print is included here that is known to have been made substantially after the negative, the date of the print is also given, or the notation *printed later* appended.

The plates are reproduced to suggest the relative size of the originals.

J.S.

LIST OF PLATES

All photographs are gelatin silver prints.

Frontispiece
CLOUDS, KINGS RIVER DIVIDE,
SIERRA NEVADA
1936 (1935)
7 5/16 x 9 5/16 in. (18.6 x 23.7 cm)
National Archives, Washington, D.C.,
79-AAH-24

1. FALL IN UPPER TENAYA CANYON,
YOSEMITE NATIONAL PARK,
CALIFORNIA
CA. 1920
4 1/8 x 2 15/16 in. (10.5 x 7.5 cm)
The Museum of Modern Art, New York.
Gift of the photographer

2. VERNAL FALL THROUGH TREE,
YOSEMITE VALLEY
1920
4 x 3 in. (10.2 x 7.6 cm)
Michael and Jeanne Adams

3. MERCED PEAK FROM RED PEAK,
YOSEMITE
CA. 1920
2 7/8 x 3 7/8 in. (7.3 x 9.8 cm)
Michael and Jeanne Adams

4. MOUNT CLARENCE KING,
SIERRA NEVADA, CALIFORNIA
CA. 1923 (1927)
4 1/2 x 3 1/2 in. (11.4 x 8.9 cm)
Michael and Jeanne Adams

5. ROCK FACE AND TREES IN WINTER
1928
5 9/16 x 7 5/8 in. (14.2 x 19.3 cm)
George Eastman House

6. MOUNT LYELL AND MOUNT
MACLURE, HEADWATERS OF
TUOLUMNE RIVER, YOSEMITE
1929
5 5/8 x 7 5/8 in. (14.3 x 19.4 cm)
Michael and Jeanne Adams

7. MOUNT ROBSON, JASPER
NATIONAL PARK, CANADA
1928

7 11/16 x 5 11/16 in. (19.5 x 14.5 cm)
Margaret Weston, Weston Gallery, Inc.

8. EAGLE DANCE, SAN ILDEFONSO
PUEBLO, NEW MEXICO
1928–29
5 5/8 x 7 11/16 in. (14.3 x 19.5 cm)
The Lane Collection

9. GRASS AND WATER,
TUOLUMNE MEADOWS, YOSEMITE
NATIONAL PARK
CA. 1935
4 9/16 x 5 3/4 in. (11.6 x 14.6 cm)
The Museum of Modern Art, New York.
Gift of the photographer

10. POOL, TUOLUMNE MEADOWS
CA. 1935
4 9/16 x 6 5/8 in. (11.6 x 16.8 cm)
The Lane Collection

11. LEAVES ON POOL
CA. 1935
4 9/16 x 6 5/16 in. (11.6 x 16.0 cm)
The Lane Collection

12. GRASS AND POOL
CA. 1935
7 1/4 x 9 1/16 in. (18.4 x 23 cm)
The Museum of Modern Art, New York.
Gift of David H. McAlpin

13. MOUNT WHITNEY FROM THE
WEST, SIERRA NEVADA
CA. 1932 (1936)
7 1/4 x 9 3/16 in. (18.4 x 23.3 cm)
Center for Creative Photography, the
University of Arizona

14. CAJIMONT-BAJRION, CANADIAN
ROCKIES. Print number 36 from
the album of the Sierra Club Trip,
1928
25 1/8 x 16 1/4 x 2 3/4 in. (63.8 x
41.3 x 7 cm) closed album; 5 11/16 x
7 11/16 in. (14.5 x 19.5 cm) print
The Bancroft Library Pictorial
Collection, University of California,
Berkeley, 1971.031.1928:4a (At some
exhibition venues different pages
from this album may be shown.)

15. NEAR MOOSE PASS, CANADIAN
ROCKIES. Print number 125 from
the album of the Sierra Club Trip,
1928
25 1/8 x 16 1/3 x 3 3/4 in. (63.8 x
41.3 x 9.5 cm) closed album; 5 11/16 x
7 11/16 in. (14.5 x 19.5 cm) print
The Bancroft Library Pictorial
Collection, University of California,
Berkeley, 1971.031.1928:4b (At some
exhibition venues different pages
from this album may be shown.)

16. SIMMONS PEAK, IN THE
MACLURE FORK CANYON, YOSEMITE
CA. 1924
4 1/2 x 3 1/2 in. (11.4 x 8.9 cm)
Michael and Jeanne Adams

17. THE BACK OF HALF DOME,
YOSEMITE NATIONAL PARK,
CALIFORNIA
CA. 1920
3 3/4 x 2 13/16 in. (9.5 x 7.1 cm)
The Museum of Modern Art, New York.
Gift of the photographer

18. MOUNT WHITNEY
N.D.
7 3/4 x 5 1/2 in. (19.7 x 14.0 cm)
The Oakland Museum of California.
Gift of Mr. Francis P. Farquhar

19. BISHOPS PASS, KINGS RIVER
CANYON
1936
5 7/8 x 9 1/8 in. (14.3 x 23.2 cm)
National Archives, Washington, D.C.,
79-AAH-04

20. GLACIAL CIRQUE, MILESTONE
RIDGE, SEQUOIA NATIONAL PARK,
CALIFORNIA
CA. 1927
7 3/4 x 5 3/4 in. (19.7 x 14.6 cm)
Shaklee Corporation

21. MOUNT BREWER GROUP FROM
GLEN PASS, SIERRA NEVADA
1935
6 3/16 x 8 3/16 in. (15.7 x 20.8 cm)
Center for Creative Photography,
the University of Arizona

22. PEAK ON GLACIER RIDGE
CA. 1925
5 11/16 x 7 3/4 in. (14.5 x 19.7 cm)
Michael and Jeanne Adams

23. PINCHOT PASS, MOUNT WYNNE,
KINGS RIVER CANYON
1936 (1935)
7 3/8 x 9 1/2 in. (18.7 x 24.1 cm)
National Archives, Washington, D.C.,
79-AAH-12

24. ROCKS, BAKER BEACH,
SAN FRANCISCO, CALIFORNIA
CA. 1931, printed later
7 3/4 x 10 1/16 in. (19.7 x 25.5 cm)
The Museum of Modern Art, New York.
Gift of the photographer

25. HELMET ROCK, LANDS END,
SAN FRANCISCO
1918, print ca. 1972
8 1/2 x 11 3/8 in. (21.6 x 28.9 cm)
San Francisco Museum of Modern Art.
Gift of Alfred Fromm, Otto Meyer, and
Louis Petri, San Francisco

26. DEAD TREE, DOG LAKE,
YOSEMITE NATIONAL PARK
CA. 1936 (1933)
6 3/4 x 4 3/8 in. (17.2 x 11.1 cm)
The Lane Collection

27. WANDA LAKE, NEAR MUIR PASS,
KINGS CANYON NATIONAL PARK
CA. 1934, printed later
9 x 11 5/8 in. (22.9 x 29.5 cm)
Anonymous

28. IN JOSHUA TREE NATIONAL
MONUMENT, CALIFORNIA
1942, print 1950
7 5/8 x 9 1/2 in. (19.4 x 24.1 cm)
San Francisco Museum of Modern Art.
Gift of Ansel Adams in memory of
Albert M. Bender

29. ROCKS, ALABAMA HILLS
CA. 1935
17 3/8 x 22 1/16 in. (44.1 x 56.1 cm)
George Eastman House

30. METAMORPHIC ROCKS, SIERRA
FOOTHILLS
CA. 1945
7 7/16 x 9 3/8 in. (18.9 x 23.8 cm)
Michael and Jeanne Adams

31. MOON AND ROCK, JOSHUA TREE
NATIONAL MONUMENT
1948
10 5/8 x 13 9/16 in. (27.0 x 34.5 cm)
Center for Creative Photography,
the University of Arizona

32. LAKE AND CLIFFS, SIERRA
NEVADA
1932, print 1934
7 1/8 x 9 3/8 in. (18.1 x 23.8 cm)
Shaklee Corporation

33. GLACIAL BOULDERS, CATHEDRAL
RANGE, YOSEMITE NATIONAL PARK,
CALIFORNIA
CA. 1936
3 11/16 x 4 1/2 in. (9.3 x 11.5 cm)
Center for Creative Photography,
the University of Arizona

34. BASE OF WEST ARCH,
RAINBOW BRIDGE NATIONAL
MONUMENT, UTAH
1942
13 1/4 x 9 1/4 in. (33.7 x 23.5 cm)
Center for Creative Photography,
the University of Arizona

35. DEAD TREES, WINTER,
NEAR CARSON CITY, NEVADA
1960
9 5/16 x 11 7/8 in. (23.6 x 30.2 cm)
Center for Creative Photography,
the University of Arizona

36. DEAD OAK TREE, SIERRA
FOOTHILLS, ABOVE SNELLING
1938
7 3/8 x 9 7/16 in. (18.7 x 24.0 cm)
Michael and Jeanne Adams

37. TREES, WINTER EVENING,
YOSEMITE VALLEY
N.D.
15 1/4 x 18 3/4 in. (38.8 x 47.6 cm)
Center for Creative Photography,
the University of Arizona

38. IN THE SIERRA NEVADA
CA. 1932
8 1/2 x 6 1/4 in. (21.6 x 15.9 cm)
California Historical Society,
San Francisco

39. TWO DEAD TREES AGAINST
BLACK SKY, SIERRA NEVADA
1925
7 7/8 x 5 5/8 in. (20.0 x 14.3 cm)
Michael and Jeanne Adams

40. SNAG NEAR SCOTIA,
CALIFORNIA
N.D.
6 1/2 x 4 5/16 in. (16.5 x 11.0 cm)
Michael and Jeanne Adams

41. DEAD TREE STUMP, SIERRA
NEVADA, CALIFORNIA
1936
9 1/4 x 6 3/8 in. (23.5 x 16.2 cm)
The Museum of Modern Art, New York.
Gift of Dorothy Norman

42. TREE DETAIL, STUMP WITH
BIRDWING SHAPE
N.D.
6 3/16 x 8 1/4 in. (15.7 x 21.0 cm)
Michael and Jeanne Adams

43. TREE DETAIL, SIERRA NEVADA
1936
6 3/4 x 8 3/4 in. (17.1 x 22.2 cm)
Michael and Jeanne Adams

44. WOOD DETAIL,
ERODED STUMP WITH KNOTHOLE
N.D.
8 3/4 x 6 5/16 in. (22.2 x 16.0 cm)
Michael and Jeanne Adams

45. DETAIL JUNIPER WOOD,
SIERRA NEVADA, CALIFORNIA
CA. 1927, print 1933
8 11/16 x 6 3/16 in. (22.1 x 15.7 cm)
The J. Paul Getty Museum, Los Angeles

46. LEAVES, SCREEN SUBJECT, MILLS COLLEGE, CALIFORNIA
CA. 1931
5 3/4 x 7 1/4 in. (14.6 x 18.4 cm)
San Francisco Museum of Modern Art. The Henry Swift Collection, Gift of Florence Alston Swift

47. LOCUST TREES IN SNOW, YOSEMITE VALLEY
CA. 1929
6 15/16 x 8 13/16 in. (17.6 x 22.4 cm)
Center for Creative Photography, the University of Arizona

48. ASPENS, DAWN, DOLORES RIVER CANYON, COLORADO
1937
6 x 8 3/8 in. (15.2 x 21.2 cm)
George Eastman House

49. SAGUARO, NEAR PHOENIX, ARIZONA
CA. 1932
3 9/16 x 4 9/16 in. (9.1 x 11.6 cm)
Margaret Weston, Weston Gallery, Inc.

50. CEDAR TREE, WINTER, YOSEMITE VALLEY
CA. 1935, print ca. 1972
6 1/2 x 4 3/8 in. (16.5 x 11.1 cm)
San Francisco Museum of Modern Art. Gift of Alfred Fromm, Otto Meyer, and Louis Petri, San Francisco

51. OAK TREE, AUTUMN, YOSEMITE VALLEY, CALIFORNIA
N.D.
9 1/2 x 6 13/16 in. (24.1 x 17.3 cm)
Michael and Jeanne Adams

52. AUTUMN TREE AGAINST CATHEDRAL ROCKS, YOSEMITE
CA. 1944
9 7/16 x 7 3/8 in. (24 x 18.7 cm)
The Museum of Modern Art, New York. Gift of David H. McAlpin

53. OAK TREE, SNOWSTORM, YOSEMITE
1948
9 1/4 x 7 5/16 in. (23.5 x 18.6 cm)
The Museum of Modern Art, New York. Gift of the photographer

54. SURF SEQUENCE
1940
8 x 9 5/8 in. (20.3 x 24.5 cm)
The Museum of Modern Art, New York. Purchase

55. SURF SEQUENCE
1940
8 x 9 5/8 in. (20.3 x 24.5 cm)
The Museum of Modern Art, New York. Purchase

56. SURF SEQUENCE
1940
8 x 10 1/8 in. (20.3 x 25.7 cm)
The Museum of Modern Art, New York. Anonymous gift

57. SURF SEQUENCE
1940
8 x 9 5/8 in. (20.3 x 24.5 cm)
The Museum of Modern Art, New York. Anonymous gift

58. SURF SEQUENCE
1940
8 x 9 5/8 in. (20.3 x 24.5 cm)
The Museum of Modern Art, New York. Anonymous gift

59. IN GOLDEN CANYON, DEATH VALLEY
CA. 1946
7 7/16 x 9 7/16 in. (18.9 x 24.0 cm)
George Eastman House

60. SUMMIT OF MOUNT RESPLENDENT, CANADIAN ROCKIES
1928
5 7/8 x 7 15/16 in. (15.0 x 20.1 cm)
George Eastman House

61. TENAYA LAKE, MOUNT CONNESS, YOSEMITE NATIONAL PARK, CALIFORNIA
CA. 1946
7 7/16 x 9 3/8 in. (18.9 x 23.8 cm)
Michael and Jeanne Adams

62. HALF DOME, COTTONWOOD
TREES, YOSEMITE VALLEY
CA. 1932
8 9/16 x 12 3/16 in. (21.7 x 30.9 cm)
Center for Creative Photography,
the University of Arizona

63. NORTH DOME FROM
GLACIER POINT
CA. 1937
7 7/16 x 9 1/4 in. (18.9 x 23.5 cm)
The Lane Collection

64. GLACIER POLISH, LYELL FORK OF
THE MERCED RIVER, YOSEMITE
NATIONAL PARK
CA. 1935
9 9/16 x 7 3/16 in. (24.3 x 18.3 cm)
Michael and Jeanne Adams

65. GRAND CANYON NATIONAL PARK,
FROM YAVAPAI POINT
1942
7 1/2 x 9 7/16 in. (19.0 x 23.9 cm)
Center for Creative Photography,
the University of Arizona

66. GRAND CANYON NATIONAL PARK,
FROM POINT SUBLIME
1942
9 9/16 x 7 7/16 in. (24.3 x 18.9 cm)
Center for Creative Photography,
the University of Arizona

67. GOING TO THE SUN MOUNTAINS,
GLACIER NATIONAL PARK
1941–42
7 7/16 x 9 3/16 in. (18.9 x 23.3 cm)
National Archives, Washington D.C.,
79-AAE-12

68. NORTH PALISADES, FROM WINDY
POINT, KINGS RIVER CANYON
1936
8 3/16 x 6 1/4 in. (20.8 x 15.9 cm)
National Archives, Washington, D.C.,
79-AAH-20

69. TRAILSIDE, NEAR JUNEAU,
ALASKA
1947
12 3/8 x 9 3/8 in. (31.4 x 23.8 cm)
Center for Creative Photography, the
University of Arizona

70. GRASS (SEQUENCE), YOSEMITE
VALLEY
1944
7 1/2 x 9 1/4 in. (19.0 x 23.5 cm)
The Art Museum, Princeton University.
Gift of David Hunter McAlpin,
Class of 1920

71. GRASS (SEQUENCE), YOSEMITE
VALLEY
1944
7 1/2 x 9 1/4 in. (19.0 x 23.5 cm)
The Art Museum, Princeton University.
Gift of David Hunter McAlpin,
Class of 1920

72. LAKE MCDONALD, GLACIER
NATIONAL PARK, MONTANA
1942
7 1/4 x 9 7/16 in. (18.4 x 24.0 cm)
National Archives, Washington, D.C.,
79-AAE-19

73. LAKE MCDONALD, GLACIER
NATIONAL PARK, MONTANA
1942
6 13/16 x 9 5/16 in. (17.3 x 23.7 cm)

National Archives, Washington, D.C.,
79-AAE-14

74. LAKE MCDONALD, GLACIER
NATIONAL PARK, MONTANA
1942
7 1/16 x 9 1/2 in. (19.1 x 24.1 cm)
The Museum of Modern Art, New York.
Gift of David H. McAlpin

75. ROCKS AND GRASS, MORAINE
LAKE, SEQUOIA NATIONAL PARK,
CALIFORNIA
1936
9 1/8 x 11 1/4 in. (23.2 x 28.6 cm)
The Museum of Modern Art, New York.
Gift of the photographer

76. RAIN, BEARTRACK COVE, GLACIER
BAY NATIONAL MONUMENT, ALASKA
1949
7 1/16 x 9 5/16 in. (17.9 x 23.7 cm)
San Francisco Museum of Modern Art.
Gift of Ansel Adams in memory of
Albert M. Bender

77. OLD FAITHFUL, YELLOWSTONE
NATIONAL PARK
1941–42
9 3/16 x 6 11/16 in. (23.3 x 17.0 cm)
National Archives, Washington, D.C.,
79-AAT-09

78. OLD FAITHFUL GEYSER, YELLOW-
STONE NATIONAL PARK, WYOMING
1942
12 15/16 x 9 3/8 in. (32.9 x 23.8 cm)
Center for Creative Photography,
the University of Arizona

79. OLD FAITHFUL GEYSER, YELLOW-
STONE NATIONAL PARK, WYOMING
1942
13 11/16 x 9 3/4 in. (34.8 x 24.7 cm)
Center for Creative Photography,
the University of Arizona

80. OLD FAITHFUL GEYSER,
LATE EVENING, YELLOWSTONE
NATIONAL PARK, WYOMING
1942, print 1950
9 1/2 x 7 1/4 in. (24.1 x 18.4 cm)
San Francisco Museum of Modern Art.

Gift of Ansel Adams in memory of
Albert M. Bender

81. OLD FAITHFUL GEYSER,
YELLOWSTONE NATIONAL PARK,
WYOMING
1942
9 5/16 x 6 1/2 in. (23.7 x 16.5 cm)
The Museum of Modern Art, New York.
Gift of David H. McAlpin

82. BROAD STREET, NEW YORK CITY
ca. 1949
6 5/16 x 4 1/2 in. (16.0 x 11.5 cm)
The Art Museum, Princeton University.
Gift of Sarah Sage McAlpin,
honorary member, Class of 1920

83. THUNDERCLOUD, ELLERY LAKE,
HIGH SIERRA, CALIFORNIA
1934
10 11/16 x 13 in. (27.1 x 33 cm)
The Museum of Modern Art, New York.
Gift of the photographer

84. THE BLACK GIANT, MUIR PASS,
REPRODUCED FROM "SIERRA
NEVADA: THE JOHN MUIR TRAIL"
CA. 1934
Closed: 16 7/8 x 12 3/4 x 1 1/4 in. (42.9 x
32.4 x 3.2 cm); image: 5 7/16 x 7 in.
(13.8 x 17. 8 cm).
San Francisco Museum of Modern Art
Library. Gift of Mrs. Walter Haas

85. WINTER SUNRISE, SIERRA
NEVADA FROM LONE PINE,
CALIFORNIA
1944
6 1/2 x 9 1/8 in. (16.5 x 23.1 cm)
The Art Museum, Princeton University.
Gift of David Hunter McAlpin,
Class of 1920

86. YOSEMITE VALLEY, CLEARING
THUNDERSTORM FROM TUNNEL
ESPLANADE, CALIFORNIA
CA. 1972
10 x 13 11/16 in. (25.4 x 34.8 cm)
The Museum of Modern Art, New York.
Gift of the photographer

87. YOSEMITE VALLEY,
YOSEMITE NATIONAL PARK
CA. 1935
14 1/4 x 19 5/16 in. (36.2 x 49.1 cm)
The Museum of Modern Art, New York.
Gift of the photographer

88. YOSEMITE VALLEY,
THUNDERSTORM
CA. 1949
24 x 30 15/16 in. (61.0 x 78.6 cm)
The Art Museum, Princeton University.
Gift of David Hunter McAlpin,
Class of 1920

89. CLEARING WINTER STORM,
YOSEMITE VALLEY, CALIFORNIA
1942 or earlier, print ca. 1963
12 1/8 x 14 1/8 in. (30.8 x 35.9 cm)
The Museum of Modern Art, New York.
Purchase

90. FLOWERS AND ROCK, SAN
JOAQUIN SIERRA
1936
8 9/16 x 5 3/4 in. (21.7 x 14.6 cm)
Center for Creative Photography,
the University of Arizona

91. UPPER YOSEMITE FALL,
YOSEMITE VALLEY
1946
13 1/16 x 9 15/16 in. (33.2 x 25.2 cm)
Center for Creative Photography,
the University of Arizona

92. EL CAPITAN FALL,
YOSEMITE VALLEY
N.D.
9 1/4 x 7 1/16 in. (23.5 x 18.0 cm)
Center for Creative Photography,
the University of Arizona

93. NEVADA FALL, YOSEMITE
NATIONAL PARK, CALIFORNIA
CA. 1946
9 3/16 x 7 3/16 in. (23.4 x 18.2 cm)
Center for Creative Photography,
the University of Arizona

94. LOWER YOSEMITE FALL,
YOSEMITE VALLEY, CALIFORNIA
CA. 1946
13 7/16 x 10 5/16 in. (34.1 x 26.2 cm)
Center for Creative Photography,
the University of Arizona

95. BASE OF UPPER YOSEMITE FALL,
YOSEMITE NATIONAL PARK
CA. 1950
9 3/16 x 12 9/16 in. (23.4 x 31.9 cm)
Center for Creative Photography,
the University of Arizona

96. MOONRISE, HERNANDEZ,
NEW MEXICO
1941, print December 16, 1948
13 3/4 x 17 5/16 in. (34.9 x 44 cm)
The J. Paul Getty Museum, Los Angeles

97. MOUNT WILLIAMSON, SIERRA
NEVADA, FROM MANZANAR,
CALIFORNIA
CA. 1944, print 1978
7 9/16 x 9 5/16 in. (19.2 x 23.7 cm)
The Museum of Modern Art, New York.
Gift of the photographer

98. LATE AUTUMN EVENING,
MERCED RIVER CANYON, YOSEMITE
NATIONAL PARK
CA. 1947
7 1/2 x 9 1/2 in. (19.1 x 24.1 cm)
Michael and Jeanne Adams

99. EARLY MORNING, MERCED
RIVER, YOSEMITE VALLEY,
CALIFORNIA
CA. 1950, print ca. 1978
9 5/8 x 12 7/8 in. (24.5 x 32.7 cm)
The Museum of Modern Art, New York.
Gift of the photographer

100. CYPRESS AND FOG, PEBBLE
BEACH, CALIFORNIA
1967
9 13/16 x 12 15/16 in. (24.9 x 32.9 cm)
Center for Creative Photography,
the University of Arizona

101. STUMP, TRINIDAD HEAD,
NORTHERN CALIFORNIA
1966
11 3/4 x 10 in. (29.9 x 25.4 cm)

Center for Creative Photography,
the University of Arizona

102. HEAVEN'S PEAK
1941–42
7 7/16 x 9 7/16 in. (18.9 x 24.0 cm)
National Archives, Washington, D.C.,
79-AAE-17

103. MERCED RIVER, CLIFFS OF
CATHEDRAL ROCKS, AUTUMN, FROM
"PORTFOLIO III: YOSEMITE VALLEY"
1939
7 3/8 x 9 1/8 in. (18.7 x 23.2 cm)
The Museum of Modern Art, New York.
Gift of David H. McAlpin

104. ASPENS, NORTHERN
NEW MEXICO
1958, print 1958–60
14 1/8 x 17 1/2 in. (35.9 x 44.5 cm)
The Museum of Modern Art, New York.
Gift of Shirley C. Burden

105. ASPENS, NORTHERN
NEW MEXICO
1958, print 1976
17 7/8 x 22 5/8 in. (45.4 x 57.5 cm)
The Museum of Modern Art, New York.
Gift of the photographer in honor of
David H. McAlpin

106. SANTA ELENA CANYON, BIG
BEND NATIONAL PARK, TEXAS
1947, printed later
14 5/8 x 18 1/2 in. (37.1 x 47 cm)
Collection of Andrea Gray Stillman

107. THUNDERSTORM OVER THE
GREAT PLAINS, NEAR CIMARRON,
NEW MEXICO
1961
14 x 18 1/16 in. (35.6 x 47.5 cm)
Michael and Jeanne Adams

108. BUFFALO DANCE, SAN ILDE-
FONSO PUEBLO, NEW MEXICO
1928
5 9/16 x 7 3/4 in. (14.3 x 19.7 cm)
The Lane Collection

109. MOUNT MCKINLEY AND
WONDER LAKE, ALASKA
1948, print 1949
7 7/16 x 9 5/16 in. (18.9 x 23.7 cm)
The Museum of Modern Art, New York.
Gift of David H. McAlpin

110. MOUNT MCKINLEY AND
WONDER LAKE, MOUNT MCKINLEY
NATIONAL PARK, ALASKA
1948, print 1978
15 1/8 x 19 1/8 in. (38.4 x 48.6 cm)
The Museum of Modern Art, New York.
Gift of the photographer

111. HOPI BUTTE, MONUMENT
VALLEY, ARIZONA
ca. 1936, printed later
8 9/16 x 11 7/16 in. (21.8 x 29 cm)
Anonymous

112. EL CAPITAN, MERCED RIVER,
AGAINST SUN, YOSEMITE VALLEY,
CALIFORNIA
CA. 1950
12 5/8 x 9 3/8 in. (32.1 x 23.9 cm)

The Museum of Modern Art, New York.
Gift of the photographer

113. EL CAPITAN, SUNRISE, WINTER,
YOSEMITE NATIONAL PARK,
CALIFORNIA
CA. 1968
19 3/8 x 15 3/8 in. (49.2 x 39.1 cm)
The Museum of Modern Art, New York.
Gift of the photographer in honor of
David H. McAlpin

Figure 9, page 29: MOUNT LYELL AND
MOUNT MACLURE, YOSEMITE.
Print numbers 166–168 from the album
of the Sierra Club Trip, 1929
25 1/4 x 16 1/4 x 1/4 in. (64.1 x 41.3 x
1 cm) closed album; ca. 5 1/2 x 7 1/2
(14 x 19 cm) prints
The Bancroft Library Pictorial
Collection, University of California,
Berkeley, 1971.031.1929:4 (At some
exhibition venues different pages
from this album may be shown.)

ACKNOWLEDGMENTS

I think that I have never on any previous project received so much help, so cheerfully given, from so many friends and colleagues. This is surely a reflection of the gratitude and deep affection with which the photography world remembers Ansel Adams.

First I must thank all those who made available for study their own collections, or the institutional collections in their charge: Dr. Michael and Jeanne Adams; Jack von Euw of the Bancroft Library; Michael Duty of the California Historical Society; Trudy Wilner Stack of the Center for Creative Photography; Leonard and the late Margorie Vernon; Ellen Sharp of the Detroit Institute of Arts; Marianne Fulton of the George Eastman House; Weston Naef of the J. Paul Getty Museum; Mrs. William H. Lane; Robert Sobieszek of the Los Angeles County Museum of Art; Peter Galassi of the Museum of Modern Art; James Zeender of the National Archives; Drew Johnston of the Oakland Museum; Peter C. Bunnell of the Princeton Art Museum; Paul H. Lehman of the Shaklee Corporation; and Margaret Weston of the Weston Gallery.

The generosity of the lenders has made it possible to attempt an exhibition that has not previously been seen—one that demonstrates the evolution of Adams' artistic thought by showing prints made over the full span of his vital years as a photographer. I am profoundly grateful for their generosity.

The staff of the San Francisco Museum of Modern Art has been extremely helpful, and that of the Museum's Department of Photography indispensable. I am especially indebted to Sandra Phillips, for her unwavering support and counsel, and to Douglas Nickel, for managing with intelligence and professional skill the thousand matters necessary to turn an idea into an exhibition.

For sharing with me without reservation her incomparable knowledge of Adams' œuvre, and for her thoughtful and helpful reading of the exhibition prospectus and the introductory essay to this book, I am most deeply in debt to Andrea Gray Stillman.

Special thanks are also due Anne Hammond, who allowed me to read in manuscript her very valuable work in progress on Adams' landscape photographs.

For important assistance with a wide spectrum of research issues, I must pay deep thanks to the late Virginia Adams, Ansel Adams' wife, and to their daughter Anne Adams Helms; and also to Mary Alinder, Allison Belcher, Leslie Calmes, Keith F. Davis, Suzanne Feld, Marianne Fulton, Karen Haas, Sarah Hermanson, Cathy Keating, Susan Kismaric, Ira H. Latour, Edward McCarter, Kristin Nagel Merrill, Therese Mulligan, Dianne Nilsen, Wendy Niven, Amy Rule, Merriam Saunders, John Schaefer, John Scrymgeour, Tiffany Scrymgeour, Marcia Tiede, and Del Zogg.

The quality of the book itself is due to the intelligence and tact of Janet Swan Bush, its editor, and Steve Lamont, its copyeditor; to the sensitivity of its designer, Abbott Miller, who understands that a book's design is in service to its content; to the dedication and high standards of Sandra Klimt, in charge of its production; to the skill and imagination of Thomas Palmer, who, in consultation with Richard Benson, has fashioned the means by which Adams' chemical photographs have been re-formed into photographs in ink. Their genius would of course count for nothing without the superb Meridian Printing craftsmen, directed by Danny Frank.

Most of all, I am indebted to my great and good friend William Turnage, who nominated me for the enviable roles of author of this book and director of the exhibition that it accompanies. During the years in which this work has been in preparation, Turnage has been a constant source of assistance, encouragement, and succor. Our conversations concerning questions of interpretation have been extensive and sometimes intense, but although he knew Ansel Adams very much better than I did, he never suggested that the fact should give his understandings precedence over my own.

John Szarkowski

Designed by J. Abbott Miller and Jeremy Hoffman, Pentagram

Digital photography and tritone separations of the exhibition
prints by Thomas Palmer, in consultation with Richard Benson

Typeset in Eureka

Paper is Parilux Silk White, specially made in Toulouse, France

Printed by Meridian Printing, East Greenwich, Rhode Island

Bound by Midwest Binding, Minneapolis, Minnesota